WHERE GOD IS · THE PAINTINGS OF EMMANUEL GARIBAY

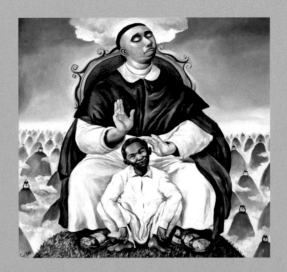

WHERE GOD IS · THE PAINTINGS OF EMMANUEL GARIBAY

With an Introduction by Rod Pattenden

OMSC Publications
New Haven, Connecticut, USA
www.omsc.org/art

© 2011, OMSC Publications

Published By
Overseas Ministries Study Center
490 Prospect Street
New Haven, CT 06511 USA
203.624.6672

ISBN: 0-9762205-6-3

Cataloguing-in-publication data is available from the Library of Congress.

Design: Yale Printing & Publishing Services
Printing: J.S. McCarthy, Augusta, Maine

Cover Image: **Santuaryo**, 1994, oil on canvas, 59^1/$_2$ x 71^5/$_8$

ACKNOWLEDGEMENTS

This book completes my art residency at the Overseas Ministries Study Center. Several people made it possible. I owe great appreciation to my wife Edna and our children Rina Lee, Gwen Nina, and Jeudi, who are my support, my inspiration, and my best friends; Jonathan Bonk, whose vision of the art residency provided new venues for mission through the arts that touch the human spirit beyond borders; Rod Pattenden, whose incisive essay captures the core essence of the thoughts and ideas in my paintings; OMSC 2010–11 residents and staff, who served as family and provided a home during our stay in New Haven, Connecticut; Sam Sigg and Dan Nicholas, who worked hard to make possible my exhibitions as well as the publication of this book; Lois Baker, whose copy editing of the text and whose suggestions helped me in realizing the quality of the final output; Loreta Juvida, Daniel Rodriguez, Joel Butuyan, Sergio Naranjilla, Jr., Ramon Orlina, Alexander Tan, and Chris Perez, who provided additional images of my paintings for this book; and relatives, friends, and associates who in one way or another helped directly or indirectly in the production of this book.

CONTENTS

PREFACE

For everything there is a season, and a time for every matter under heaven... (Eccl. 3:1)

I write this preface with mixed feelings. On the one hand, I am struck by the images in this book—stirred by their not-so-subtle provocations, challenged by their penetrating theological insights, and grateful that the artist was able to spend one year in the OMSC community, painting and exhibiting his art. On the other hand, I am saddened that this book marks the end of an era in which ten outstanding artists—nine of them Asian—were able to use OMSC as a platform from which to "speak" internationally. This is the tenth and final year of OMSC's artist-in-residence program. Perhaps it is the beginning of a mere moratorium, but to all practical effects and purposes, the uniquely vibrant program comes to an end in May of 2011.

OMSC's artists in residence have included Nalini Jayasuriya (Sri Lanka, 2001–2003); Raymond Dirks (Canada, fall 2002); Sawai Chinnawong (Thailand, 2003–2004); Wisnu Sasongko (Indonesia, 2004–2005); He Qi (China, 2005–2006); Hanna Cheriyan Varghese (Malaysia, 2006–2007); Huibing He (China, 2007–2008); Soichi Watanabe (Japan, 2008–2009); Jae-Im Kim (Korea, 2009–2010); and Emmanuel Garibay (Philippines, 2010–2011).

Initially supported by a grant from the United Board for Christian Higher Education in Asia (UBCHEA), this unique ten-year venture enabled outstanding Asian Christian artists to produce, exhibit, sell, and publish their paintings. UBCHEA saw it as a way of sustaining the artistic vision of the late Paul T. Lauby (1925–2003). Dr. Lauby, an ordained minister of the United Church of Christ, served at Silliman University in the Philippines from 1953 to 1968, and then as president of the United Board for Christian Higher Education (in New York City) from 1969 until his retirement in 1989. His interest in Asian Christian art and artists was well known, and he did much to encourage the development of emerging artists.

UBCHEA's support of OMSC's program in its critical early years was later supplemented by modest grants from First Fruit, The Henry Luce Foundation, the Foundation for Theological Education in South East Asia (FTESEA), and the Nagel Institute. Art sales provided some support in the later years of the program, but without these patrons, OMSC could not have provided opportunity for artists to live and work in New Haven. Nor would thousands of Americans have been personally affected by a genre of Asian art that gently, eloquently, and compellingly retells "the old, old story"—including the disquieting parts that we may prefer not to see, as in the case of Emmanuel Garibay! This art is an evidence of the great north-south Christian reversal now taking place, with the Glad Tidings now being proclaimed from erstwhile "uttermost parts" to Western societies jaded by outworn theologies and wearied by the transparently irrelevant "churchianity" of neo-Christendom. Through art, the false notion that most good ideas, including Christian ones, flow outward from the West is quietly but resoundingly refuted.

While the passing of an era is lamented, ten richly rewarding years of art at OMSC are to be celebrated with gratitude!

Jonathan J. Bonk
Executive Director
Overseas Ministries Study Center
New Haven, CT 06511
April 2010

When artists complete their year of residence, they frequently donate some of their art to OMSC for sale or for exhibition. Proceeds from the sale of donated art are divided equally between the artist and the artist in residence program. The art may be viewed and purchased online at www.omsc.org/art.

PAINTING PARABLES: THE ART OF EMMANUEL GARIBAY

Rod Pattenden

Art takes us on a journey. From the comfort of familiar ways of seeing, there will be moments of surprise, delight, and at times consternation as we encounter new and different ways of looking at things. This clearly presents us with a problem. Art not only presents us with things to look at, but also asks us to think more deeply about the way we see. Looking does not leave us in command of the process of seeing, for very quickly we see images looking back at us. They challenge us with their difference and create a sense of displacement and disturbance in our understanding of the order of things. Art is not child's play and it is certainly not benign and safe. Christian history is littered with arguments about the power of images, including accusations of idolatry and acts of physical violence towards artworks. This warning about the capacity of images to disrupt is an appropriate place to begin to introduce the work of Filipino artist Emmanuel Garibay.

This artist presents us with the familiar stories of the Gospel, but through the less familiar customs and lives of his own people in the Philippines. As Christian art his work ought to confirm what we know about God's world, and yet it peels back the layers to reveal a concern with injustice, the abuse of power, and most disturbingly the nature of colonialism. In looking at what I know, my sense of ground is shifted; I become part of the picture, part of the problem, part of the injustice that Garibay so sharply unfolds for the viewer. In many ways his works are like parables, and, like the parables of Jesus, they turn us as viewers or listeners upside down, disorientating us to set us eventually right side up. It is an interesting question, then, to consider how these artworks might operate as parables, how they might reimage the familiar in a manner that orients us more dynamically to the kingdom of God present within our own social context.

Garibay's work, from its earliest beginnings, has developed using a narrative style, telling graphic and direct stories of human powerlessness and hope. The sharpest feature of this storytelling is his capacity to expose the difficult tensions and unresolved questions that are always part of the experience of life. In tourist brochures Filipinos are widely advertised as being the happiest people on earth. This is an observation that Garibay views with irony as the promise of progress is consumed by widespread corruption and inequality. The Philippines has a confrontational history of Spanish and North American colonialism, and feudal values still order many features of the country's political and social life. Garibay has an eye for isolating in a single episode the ironies and ambivalence that shape a whole culture. He is a

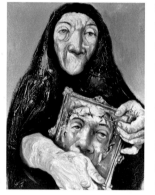

compassionate and deeply committed insider who defamiliarizes ordinary life with the possibility of an alternative future, with an eye for hope.

One of the most powerfully compassionate images that Garibay has produced is his *Pietà*. This subject traditionally depicts the mother Mary holding the body of the dead Christ. Michelangelo's famous sculpture comes to mind as the model for this intense relationship of love as Mary grieves over the death of her son. It is a powerful expression of human anguish that also reflects the divine response of grief and love towards suffering humanity. In contrast to this famous image, Garibay has reconfigured our expectations. Instead of an actual body, Mary is left to cradle a photograph. The body of Christ is absent, missing, presumed dead. In the Philippines this correlates with those who disappear, the many victims of political killings that still continue in that country. Mary's mouth has also disappeared and she is rendered speechless, silenced in her anguish. These features represent in a greater way the silencing of people's grief and protest at injustice and violence through fear and intimidation. This experience is repeated around the world where speech about justice is silenced through oppressive measures.

Unlike many artists shaped by a Christian faith who simply translate the Bible into their own ethnic clothing, Garibay has gone deeper into the cultural collisions inherent in the ministry of Jesus and the nature of power. Garibay is interested in a here and now analysis of power and how that works out in Third World situations. He sees images as being able to provide an antidote to blindness, as well as a rallying point for the imagination towards new acts of justice making. This is a model for a worldly form of faith that has much to teach complacent First World consumers. Garibay is a gracious and warm person, but his images are dangerous to comfortable illusions and especially the complacency of First World religiosity.

Having exhibited his works in Australia I have observed firsthand the discomfort of the faithful as his art chips away at our local versions of faith-based security. Audiences chuckle at his visual observations but with a growing sense of uneasiness. This is especially so when he becomes sharper in his criticisms of the organized nature of the church. For example, his rather cheerful image of a group of clergy jostling to have their picture taken turns

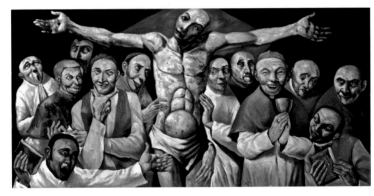

out to be none other than the twelve apostles at their reunion gathering. The usual photographic record of such an event undergoes something of a visual doubletake when we recognize the central place of the still crucified Christ. This ironic addition is somewhat distanced from the happy gathering of old classmates who congratulate themselves on their deeds well done and the achievements they have made since graduation! These good old days are somewhat lost on the crucified one.

Photos are always big moments in Filipino life; as they create history, they also capture moments as existing in time, and they celebrate life. Looking more carefully into the image we see several clergy preoccupied with their own image and how they would like to be represented. One figure frames his face with a separated finger and thumb, a local gesture that indicates how good-looking

he is. Of course, the displacement of the crucified Christ and these cheerful apostles is not lost on the viewer! Garibay commented to me that "at times, the church has preoccupied itself with the institutional issues. Here theology is all about the 'other world.' It does not engage in any confrontations with authorities or forces of power in the real world. It just serves the interests of those who are leaders."

One of the central concerns for the artist over many years has been where to locate the figure of Christ in Filipino culture. While Western artists might shy away from the direct depiction of a contemporary Christ figure as being a task fraught with difficult cultural collisions, it is something that Garibay has attempted many times. This search has not been one of simply locating its place, but rather the more difficult task of identifying the very problem of Christ in Filipino culture. Christ has been closely associated with the Spanish colonial period and more recently as part of North American consumer culture. Where does the authentic Christ image occur who is enculturated within local customs and who expresses the nature of freedom, hope, and faith that is authentically Filipino?

When the figure of Christ does appear, it is as an elusive and challenging opportunity rather than as a fixed destination of comfortable faith. In Garibay's work Christ appears variously as rich and decorated, poor and marginal, mostly indigenous and dark in complexion, and most alarmingly at one point in the guise of a woman. This makes his work rich in theological insight as we search for an authentic Jesus but keep coming across many forms of representation and meeting their inherent failure to help us believe. One of the most widely reproduced of Garibay's works and one of his most unsettling is his exploration of the episode of Emmaus in the Gospel of Luke (see pg. 15). Here members of the early church see the risen Christ as the unfamiliar one who walks alongside us, but is finally made present in the breaking of bread and the pouring out of wine. Many artists have attempted

this story because it turns on the pivotal moment of visual recognition. The dramatic and starkly lit interior scene by Caravaggio, for example, notably expresses this shock of recognition in which we the viewer see the one for whom we have longed.

In Garibay's version, Christ appears in the form of a woman dressed in a red café dress, with appropriate stigmata in her hands should we miss this physical sign of the Risen One. Her dress clearly marginalizes her within Filipino culture as a woman of possible social edginess, an outsider, perhaps a woman of ill repute. Rather irreverently, however, the disciples are laughing uproariously. They have just made the visual recognition—and what a joke! They had missed the point. When they are expecting Jesus to appear in familiar form—he actually appears as a woman. It's a joke played on them, but now they see. It's a funny story of missing true identity, but more profoundly it plays with the truth of the record to reveal another truth, and that is the difficult one of the human capacity for blindness. Some Western audiences have found this image simply too much, and yet the visual strategy is consistent with Martin Luther's idea of the resurrection as God's divine joke played on the devil. In the face of death, God creates the surprise ending and brings Jesus back to life! Consistent with this trajectory Garibay makes a theological point through the play of the image—especially the image that we have expected to see in our mind's eye. In this context, amazement is an appropriate theological response to resurrection, which should be accompanied by an equal amazement that we could have missed the point. We are exposed here to our own lack of seeing, or worse, to our inherent blindness. We say we have faith and yet we cannot see.

Garibay is on a search for Jesus in the midst of all the false prophets and priests of power. In that process he wants us to understand how images work and how they keep us from a form of seeing that will set us free. He says: "I am concerned to find a Jesus that is contextualized into our own situation, our own life and national situation. A Filipino Jesus continues to be part

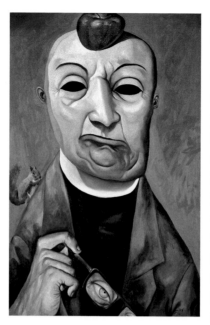

of the colonial past that is still present. This is a Jesus with a four-hundred-year history who looks white. The church continues to support this colonial view and allows it to be embellished with gold, and therefore more importantly with power and authority." Garibay reminds believers that faith can also be a form of not seeing; faith can be turned into an ideology that is used to inoculate one against complexity and, even worse, injustice. The Christ figure in his work is the one who brings surprise, at times in the form of a trickster or troublemaker. This is the one who turns over tables and who will not stay still long enough to be turned into an idol or a category to be manipulated, a banner to wage war, or even an ideal to proclaim a kingdom on this earth.

Many writers on the words of Jesus have observed this same quality in the parables, that they operate on the level of the imagination and work to turn things upside down. Seeing or experiencing the truth will at times require disruption, confusion, and moments of chaos. We tend to see things as we would like them to be. Our desire shapes our seeing. The image of Christ will then at times sharply confront the culture we inhabit; at times this image will appear as countercultural or even as dangerously marginal. At the familiar table of Emmaus, Christ appears as an unfamiliar guest. It is this visual shock that wakens us to see more clearly our tendency to wear the blinkers of our culture. Garibay at his most difficult simply exposes our blindness. We missed seeing anything; the joke is on us! But where do we see the Christ?—where do we celebrate his presence and fullness of life?

Garibay offers us a number of images that directly parody the effectiveness of the church. In a work depicting a serious academic theologian we see attributes of those who handle the words about Jesus and their capacity to see. Curiously we notice that the eyes of the theologian are contained within his glasses, and his eye sockets are otherwise empty. Garibay is critiquing the capacity of theology to serve the interests of those who resist change, who seem blind to the reality of injustice and suffering. This is sharp stuff and

arises out of Garibay's experience of the church in the Philippines that holds to the status quo, unable to critique the situation of contemporary society. The apple balancing on the theologian's head is truth-telling exercise—asking whether theology can become a purely academic exercise of words in a competitive marketplace of words. Here words become a source of prestige and career management rather than instruments for setting people free. The small squirrel on the figure's shoulder provides the counterpoint as an image of natural wisdom that creates the conditions of freedom.

Garibay wants to wake up his audience to the awareness that they are being held captive in their imagination to a form of believing that belongs to the colonial past. He uses these images to make them aware of their involvement in supporting structures of authority that oppress people. Garibay has a sophisticated awareness of how knowledge is a form of power, and that religion can be one of the most potent forms of oppression because it operates on the inside, through belief, hope, and the faith of individuals and communities. His use of parody and irony, as in the parables and the actions of Jesus, offers the possibility of an awareness that leads to freedom and hope. Translating these ideas and images into our Western context is fraught with the potential for causing offence as they poke holes in our sacred cows, or rather our favored means of exercising authority.

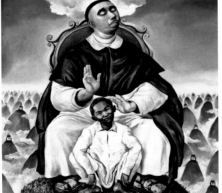

Through repeated means of authorization, through attraction based in desire, through their seeming naturalness we allow the idols of our culture to rule us and to structure our lives. Garibay's approach is therefore iconoclastic, using parody and irony to render powerless these icons of our culture and to create the possible conditions of freedom. This sense of captive imagination is clearly expressed in the work titled *Empire*. Here a Spanish friar sits atop a hill with a young indigenous boy at his feet. The Spanish friar is the symbol of the colonization or captivity of the imagination. He seems to be either blessing the boy or simply drumming on his head. Drumming, drumming, drumming

things into his head, might be a better way of expressing it. This is indoctrination rather than the freedom of the Gospel. The boy has a banana in his hand and has teeth missing in his mouth. He looks stupid or at best simple. He has been rendered barely sensible by this process, unable to think for himself. More disturbingly, this small scenario is repeated across the landscape of the work as each friar sits atop a small breast-like mountain, offering endless captivity rather than nurture.

It is so easy to look at other situations in the world where there is injustice and wonder how people put up with such things. Why don't they imagine things differently and act to free themselves? It seems that part of the process of indoctrination is to put change out of the picture and to teach people to accept the status quo, offering them small incremental tastes of privilege and power so that the system maintains itself. It is a strange phenomenon then that the oppressed will often resist being set free. This is a question that Jesus asked many of the people he encountered as he offered to heal them. Being set free from captivity can change your life in ways that you cannot conceive of or, most importantly, control. Freedom brings a dangerous responsibility to open up the future to the instability of dreams and visions. For many, this is an intolerable and terrifying option.

But Garibay does not leave us stranded as he returns us to the familiar signs of our faith. In a work that presents the holy family we see the familiar figures, father, mother, and child in an intimate family portrait (see pg. 18). Here are the signs of divine nurture and comfort. We notice that they are naked, and therefore vulnerable. We also notice that they are being driven in a jeepney, the basic form of travel for the urban poor of Manila. This is the flight to Egypt, the condition of refugees and all others who travel seeking a better life. Poverty and severe oppression force people to look for a better life of security and prosperity elsewhere. This quest is so much the condition of a world where displacement and refugee movements send millions fleeing towards the possibility of security elsewhere. The crowning

with barbed wire reminds us of the conditions of oppression, the unremitting irritant that unsettles people towards freedom and hope.

Garibay has told me that poverty is the great savior for many rural Filipinos. Their lack of resources saves them from the requirement to compete as customers for consumer items. Western companies looking for new markets in Asia intentionally accelerate the process of turning communities into consumers. I am uncomfortable with this awareness, as I know of many Western companies that use the Philippines, as well as other Third World countries, for profit and not for social improvement. Garibay's works begin to ask deeper questions of me about the manner in which I view Asia and the conditions of the Third World. I directly benefit in terms of the food, clothing, and other products I buy. In saving a few cents I may be blind to the conditions that workers may endure to support the relative comfort of my consumer lifestyle. Garibay's images are looking back at me, and that gaze is very uncomfortable.

The journey that Emmanuel Garibay takes us on is one that proves to be unsettling, but it is a journey that invites change and offers hope. Garibay believes in the power of art, in particular the capacity of images to bring insight and to change behavior. This is a thoroughly ethical and incarnational model of image making that arises from both his artistic and his theological training. His work is prickly in the context of his life in Manila as a respected mid-career artist. It is even more brittle in the cool postmodern environment of the West where we are so dependent on images to sell us our lives. Garibay continues to be involved in art making as a respected artist in his own culture as well as a constant collaborator with artistic movements and group exhibitions in Asia. He has been involved for many years in conferences and events that draw artists and other creative people together in actions for social change. There seems no other alternative for creative people within such a culture, for as an artist you live with your neighbor as your subject matter.

The art of the region shares many characteristics with the contemporary art of Africa, India, and South America in that artists are situated within communities that face poverty, violence, and political powerlessness. By necessity artists are concerned with survival, with finding a role to provoke hope and to encourage human invention in the face of overwhelming odds. This context is radically different from the art centers of the First World, where concerns about identity rein supreme. In the West, consumerism is the language of currency, while art in the Third World is far more about a revitalization of the social imagination. This is sometimes about human justice, sometimes about creating hope, and sometimes just about raising questions that provoke and prickle the conscience.

Given the aspects of human liberation and the questioning of authorities so inherent within Christian theology, Garibay is one individual who believes in the capacity to communicate images in a manner that alerts us to the conditions of human hope and resilience. For all his ironic playfulness, sharp social awareness, and conscience pricking, there remains a buoyant hope in Garibay's work, and a belief in the role of art as a cultural resource for the health of a nation's imagination. There is something simply prophetic about this quiet man's capacity for providing parables about dismantling hope that renews the capacity of the social imagination. In the West we still feel somewhat nostalgic about the possibilities of a prophetic voice within culture that offers such a sharp hope for the future. In this regard we might usefully reshuffle our colonial labels, our prejudiced tags based on race or culture, and accept Garibay's invitation to see, and then to see again.

Rod Pattenden *is a curator, art historian, and theologian who has written widely on aspects of spirituality and contemporary art. He regularly runs workshops in creativity through InterPlay Australia, is chair of the Blake Prize for Religious Art, and works as a campus minister at Macquarie University in Sydney (www.rodpattenden.id.au).*

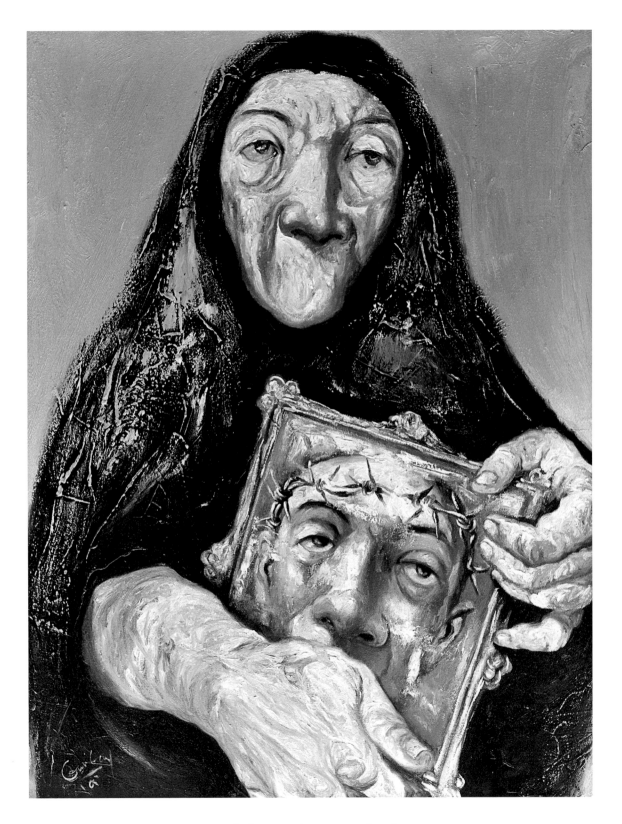

Pietà, 2005, oil on canvas, 48 x 36
This is about the victims of political repression, those whom the authorities made to disappear.

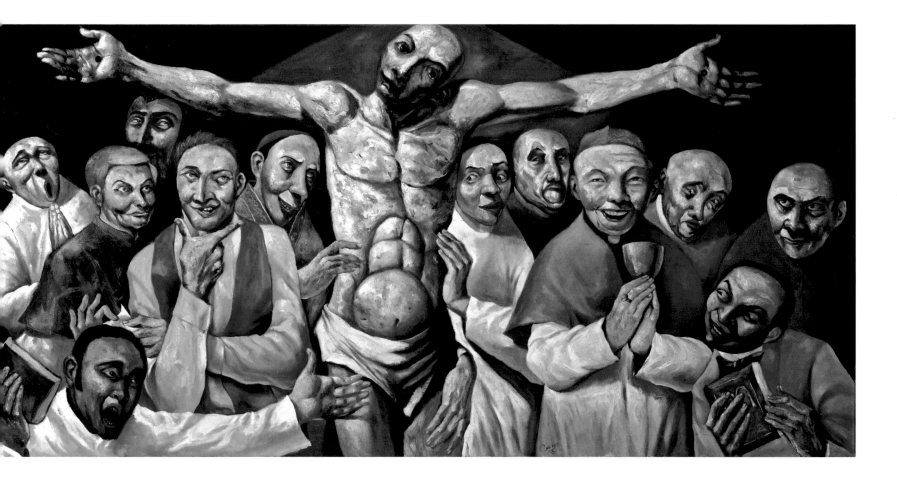

Reunion, 2010, oil on canvas, 48 x 96

Jesus and his disciples are having their photo taken at their 2,000-year reunion.

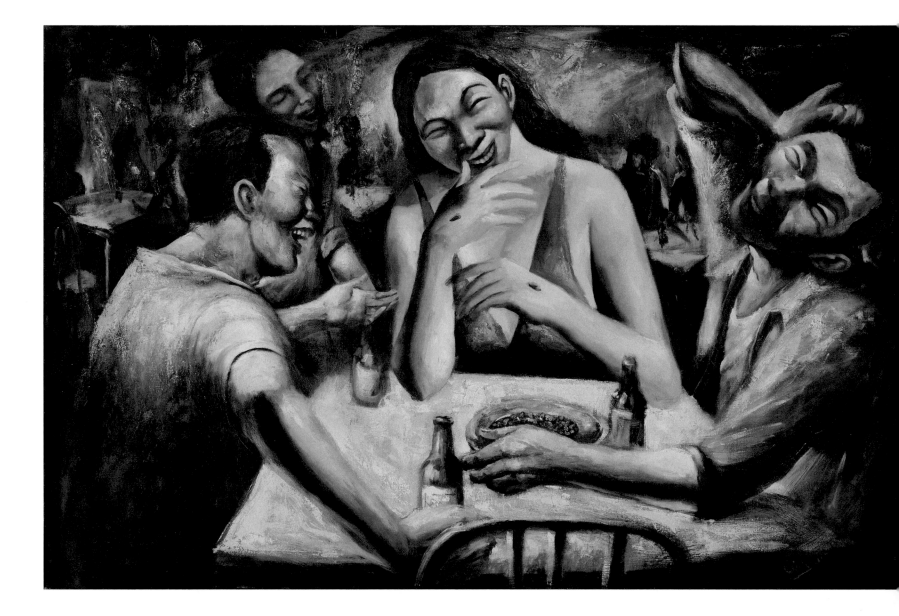

Emmaus, 2010, oil on canvas, 35 x 54 3/4

Jesus is revealed with a totally shocking and unexpected identity.

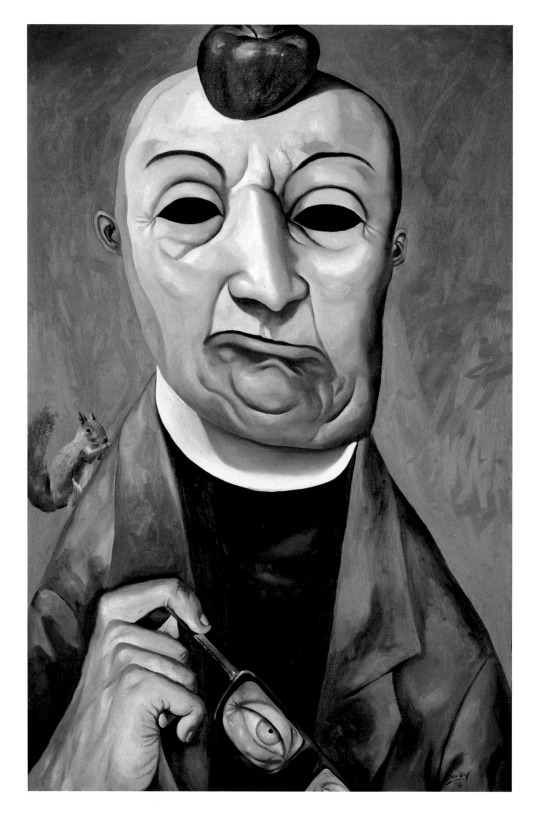

Doctrine and Wisdom, 2010, oil on canvas, 54¾ x 34¾

Cites the tendency to put institutional traditions such as doctrines and academic prestige above faithfulness to the way of God and nature.

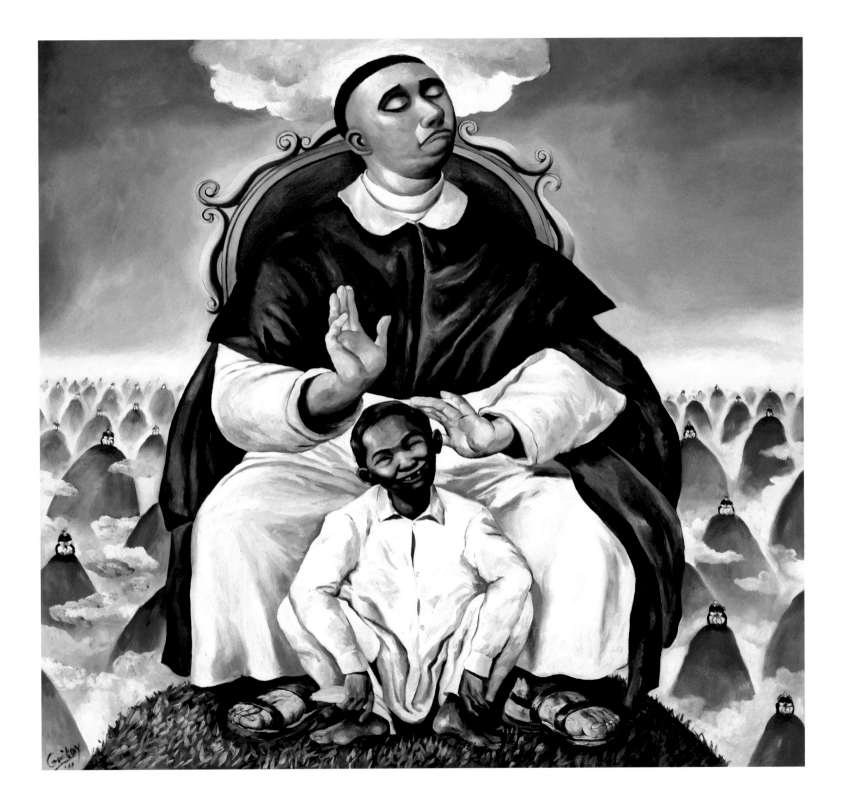

Empire, 2011, oil on canvas, 50 x 52¼
How Christendom misrepresented Christianity as a tool for colonization (empire building).

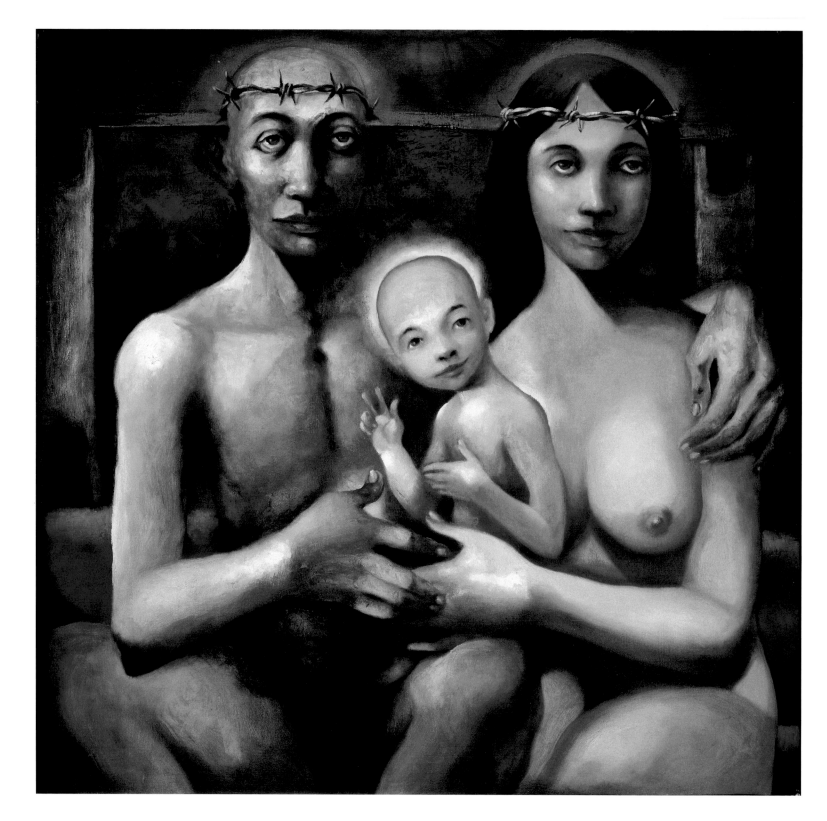

Sagrada Familia, 2010, oil on canvas, 48 x 48

In this deconstruction of the story of the flight to Egypt, poverty and injustice force a Filipino family, riding in a jeepney, to leave their homes.

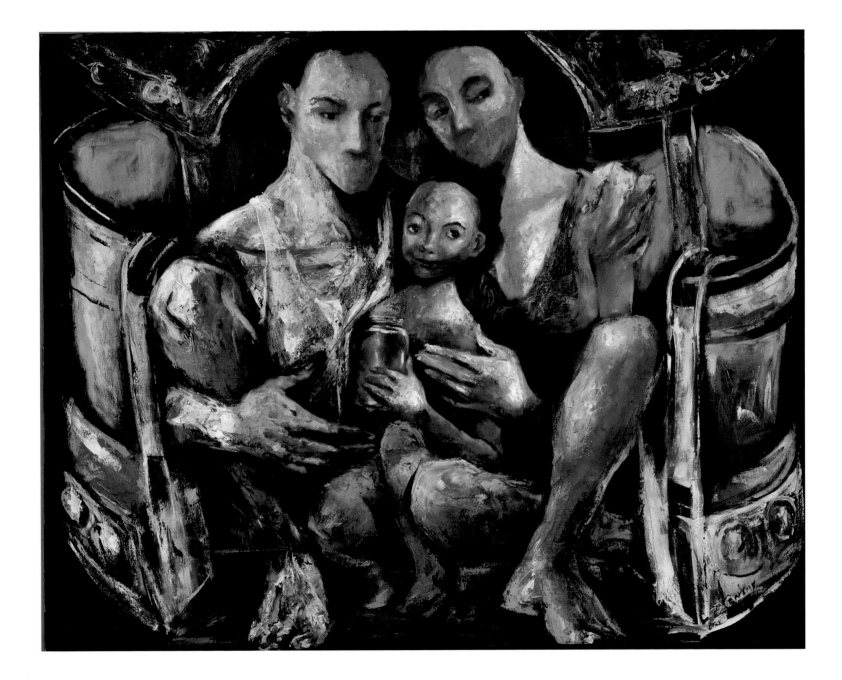

Tahanan, 2005, oil on canvas, 36 x 58

The Holy Family appears in a Philippine setting; Jesus is born in an abandoned jeepney which becomes their dwelling.

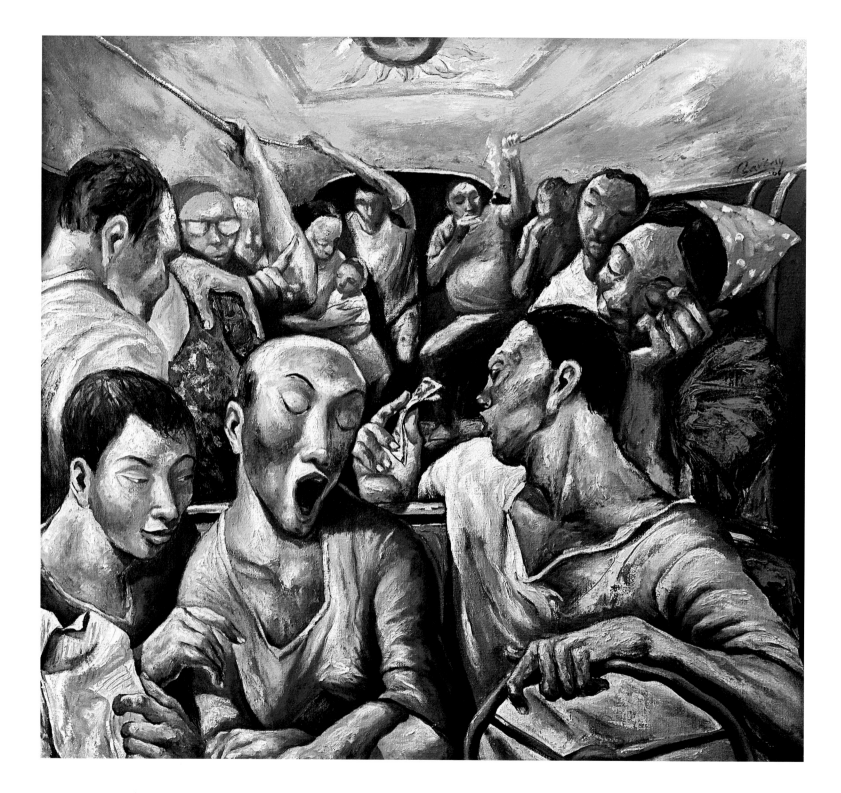

Rush Hour, 2006, oil on canvas, 48 x 48
Scene inside a jeepney.

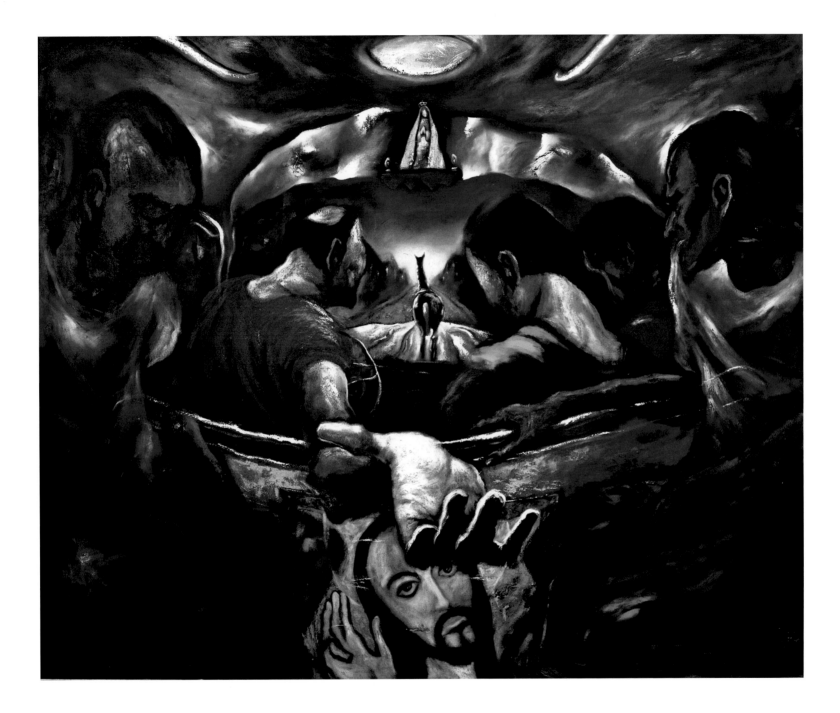

Santuaryo, 1994, oil on canvas, 59$\frac{1}{2}$ x 71$\frac{5}{8}$

Jeepney is a metaphor for a nation on a journey—suggesting a bright, hopeful destination ahead.

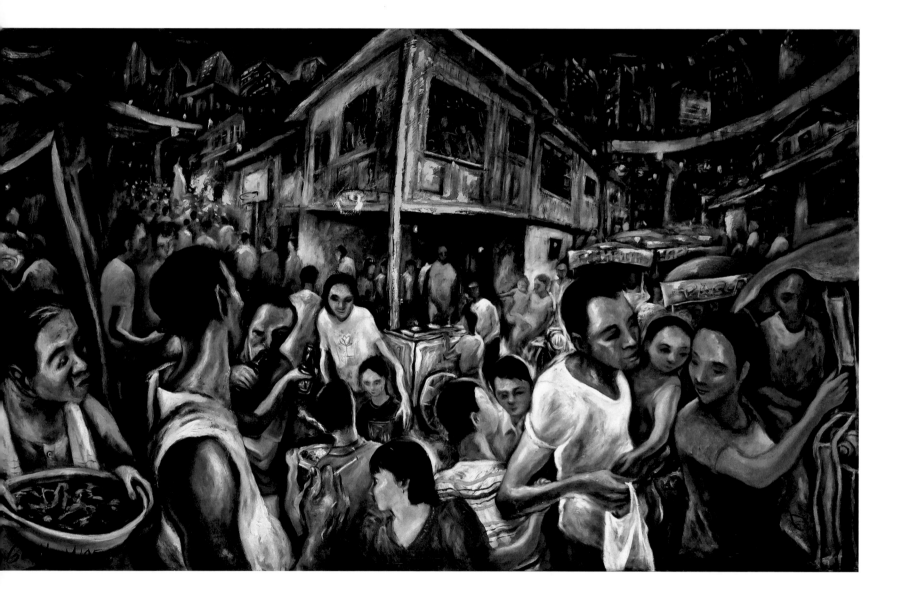

Fiesta, 1995, oil on canvas, 60 x 96½
A community of urban poor celebrating fiesta—in contrast to the dark high-rise buildings in the background.

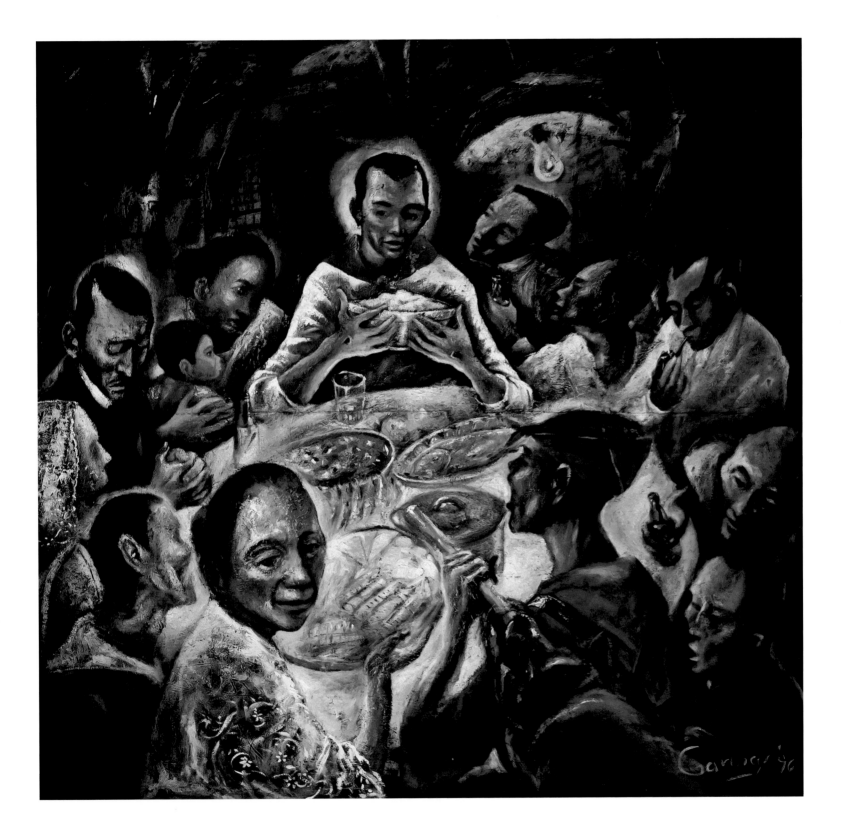

Komunyon, 1996, oil on canvas, 70 x 70

In this version of the Last Supper, Jesus and some of the disciples are played by Filipino historical personages. The women and children in the painting suggest the inclusive message of Jesus' ministry.

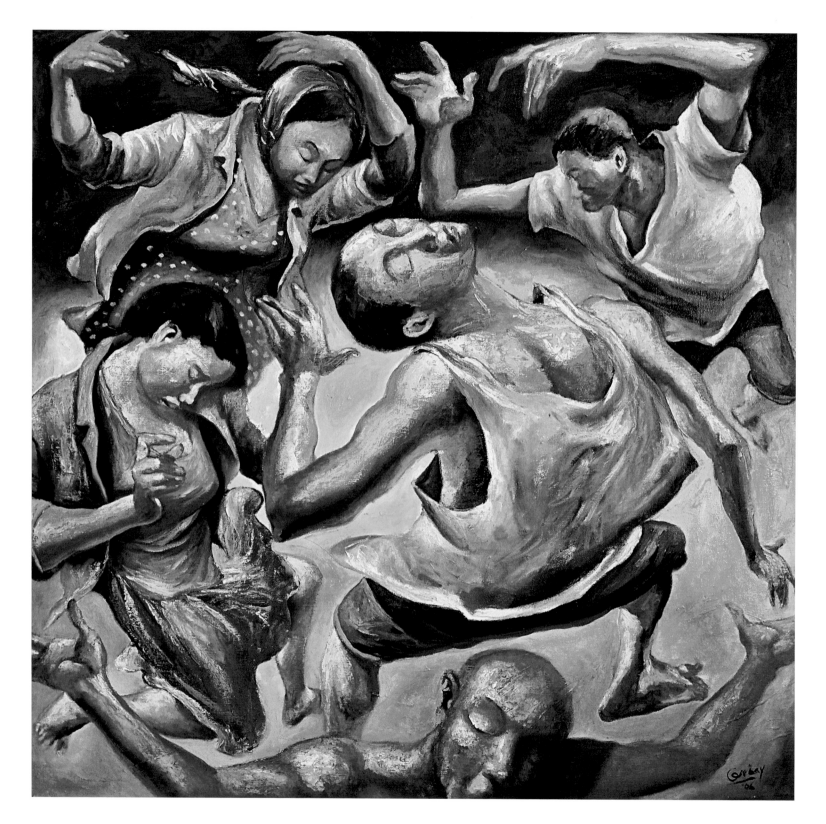

Indakan, 2006, oil on canvas, 48 x 48

Farmers dancing for the last harvest; their land will be sold for industrial and commercial use as part of the government program of land conversion.

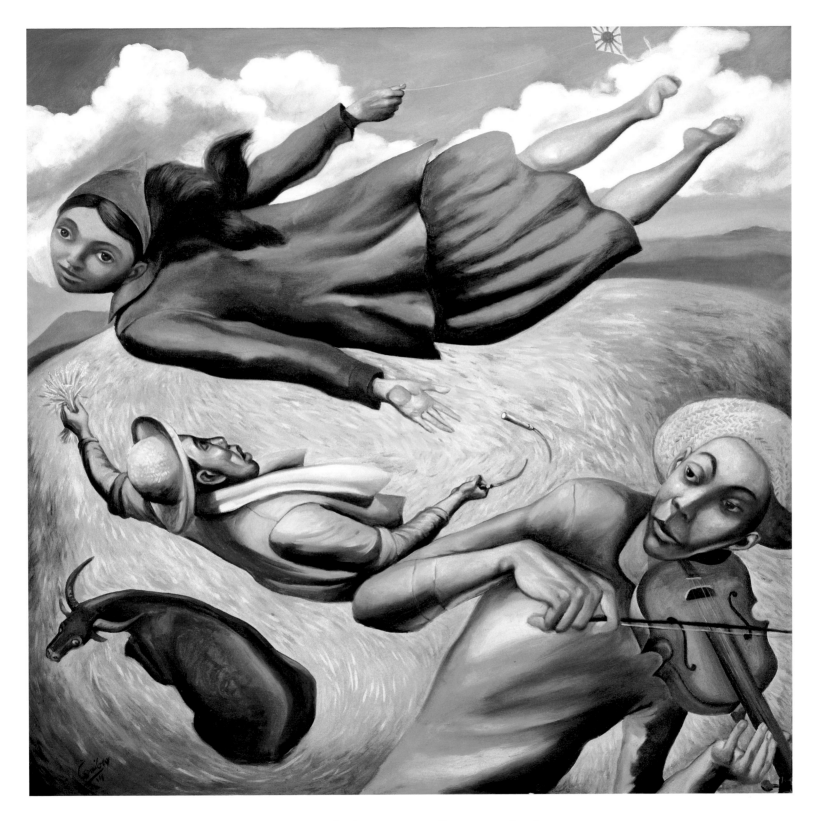

Saranggola ni Neneng, 2010, oil on canvas, 48 x 48
A story about Filipino women leaving for other countries, such as Japan, in search of a better life.

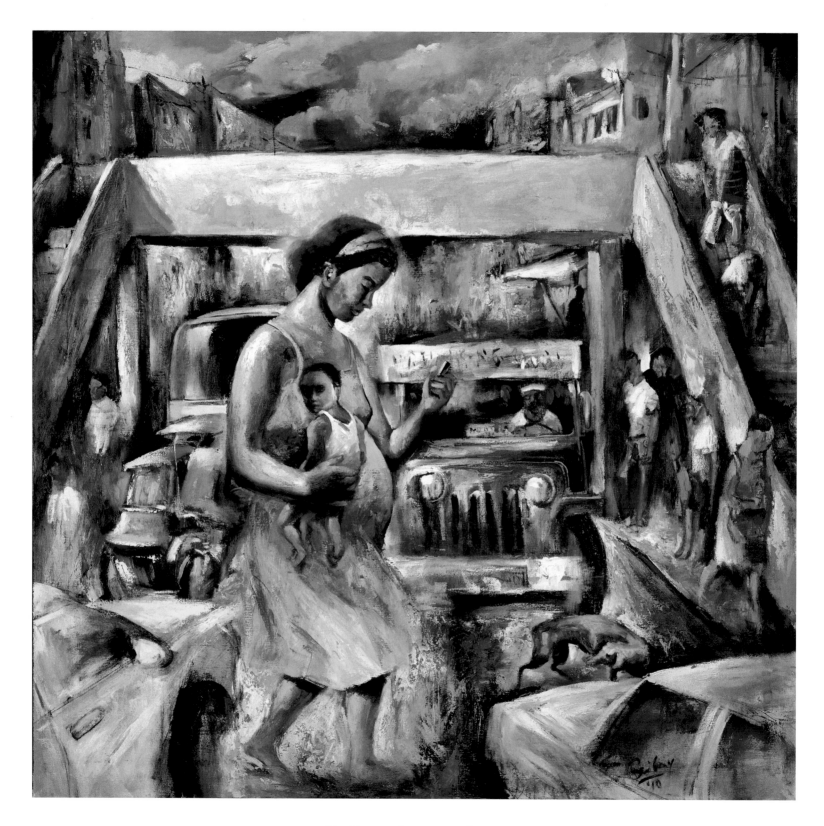

Tawid, 2010, oil on canvas, 48 x 48
About the often chaotic life in the city and the people's adaptive skills.

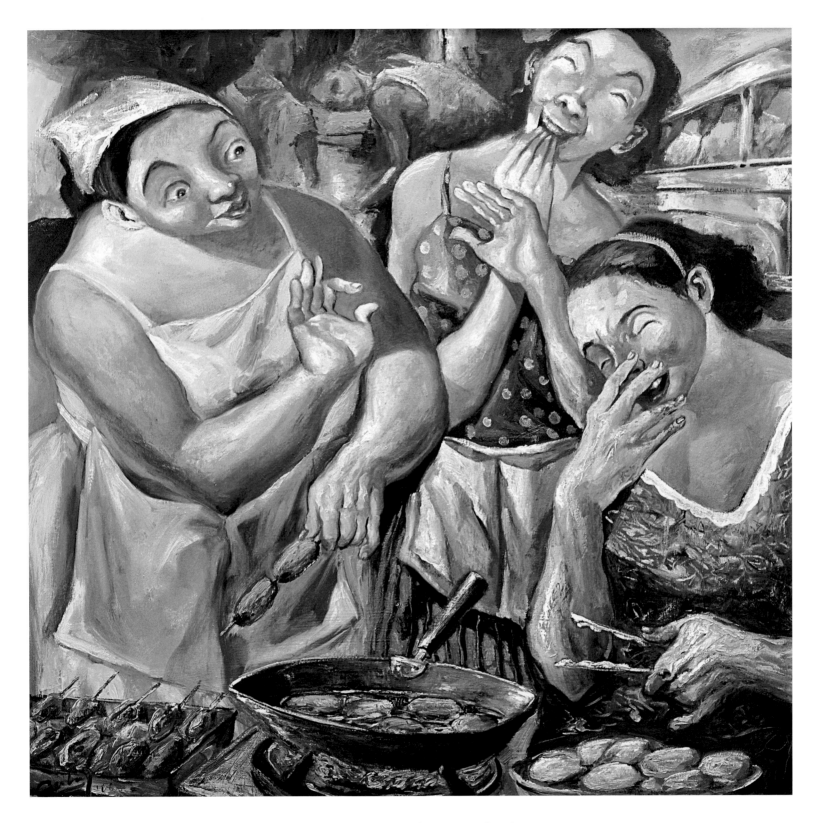

Banana Cue, 2006, oil on canvas, 48 x 48

A euphemism that gives the women market vendors a good laugh.

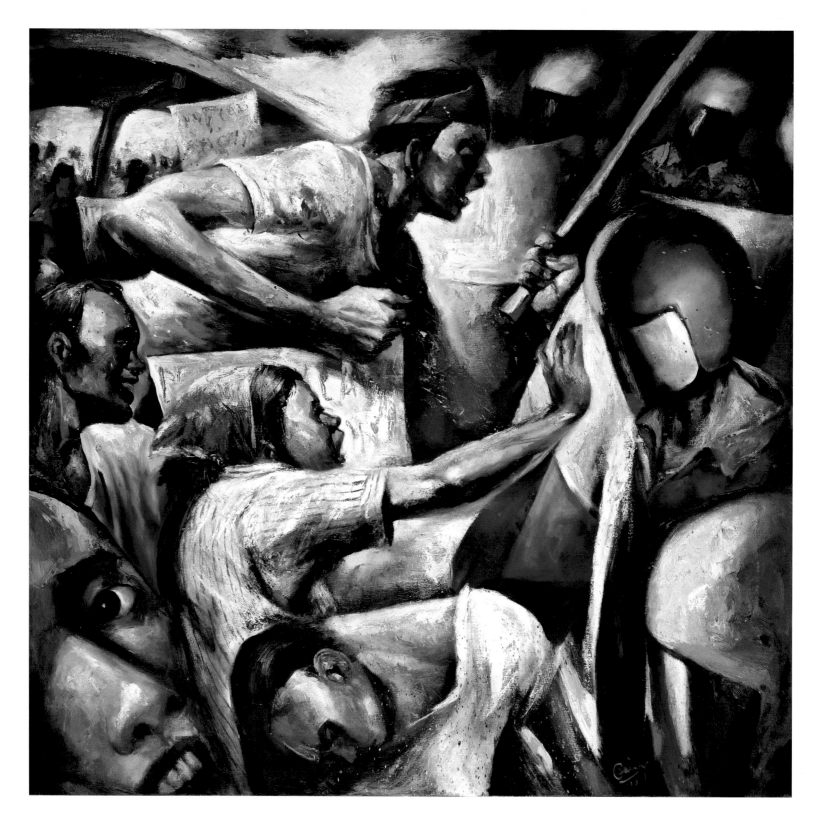

Mendiola, 2010, oil on canvas, 48 x 48

Protesters fighting for their rights are likened to Jacob wrestling with the angel in Genesis 32.

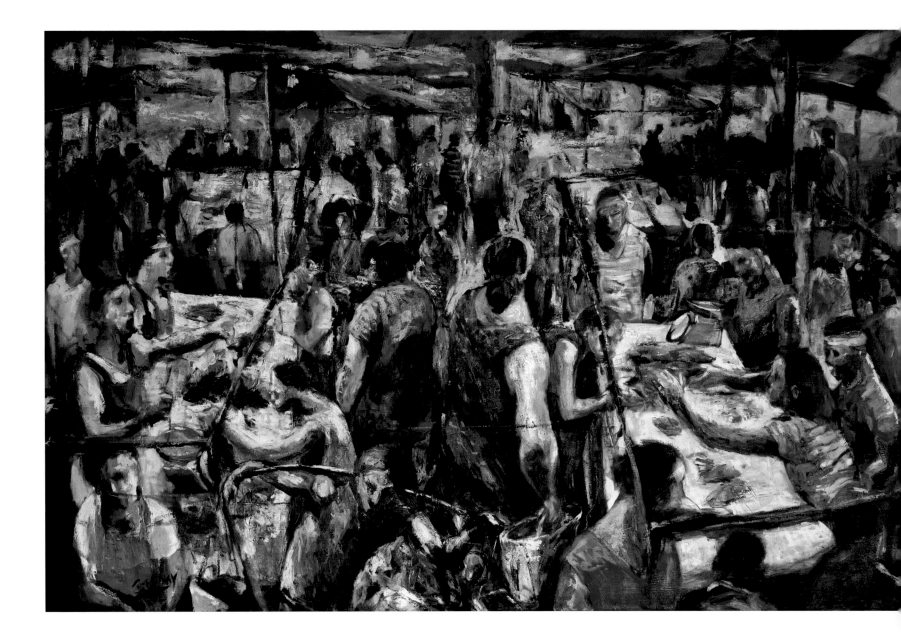

Market Scene, 2002, oil on canvas, 48 x 71⅝

Where the people are, there God is.

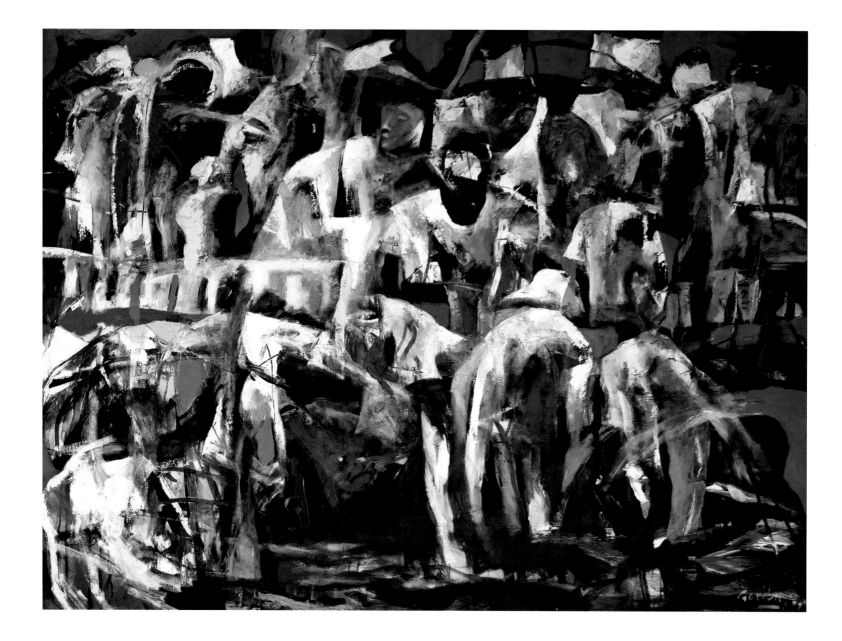

Maynila, 1999, oil on canvas, 55$\frac{1}{2}$ x 71

The struggle to seek order within chaos in the crowded city of Manila.

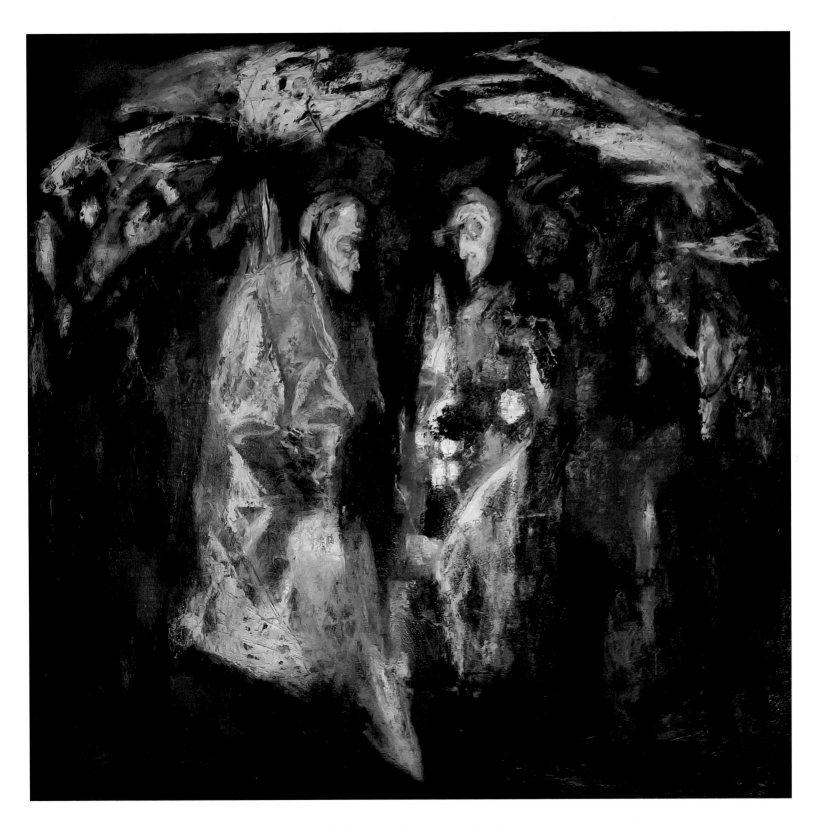

Pilgrim, 2006, oil on canvas, 48 x 48
A journey to an unknown destination.

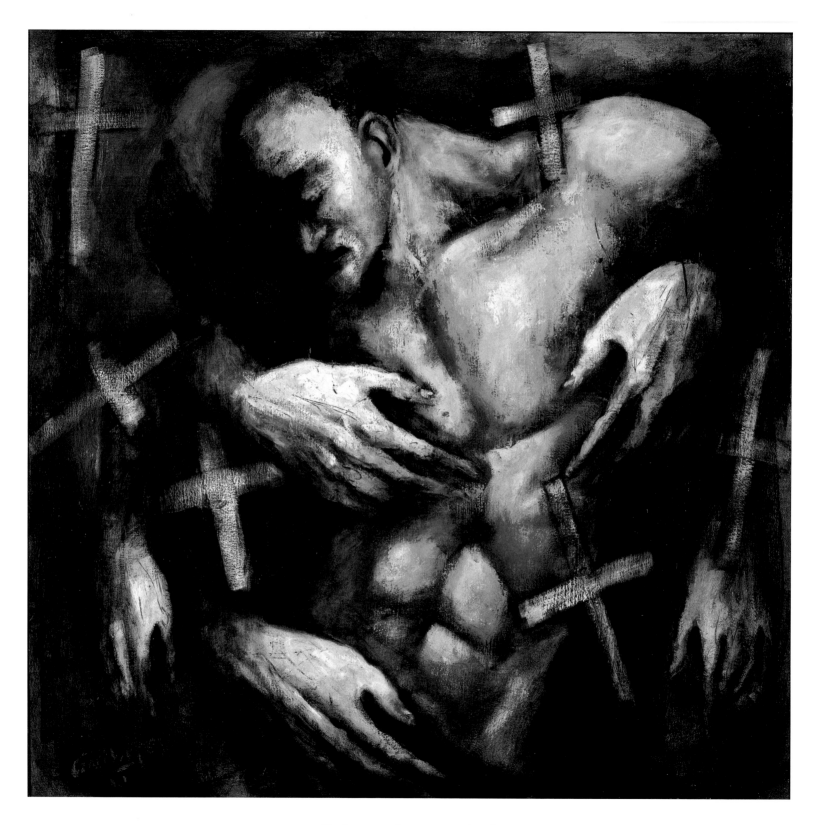

Martyr, 2010, oil on canvas, 36 x 36

The death of the faithful is the lifeblood of belief.

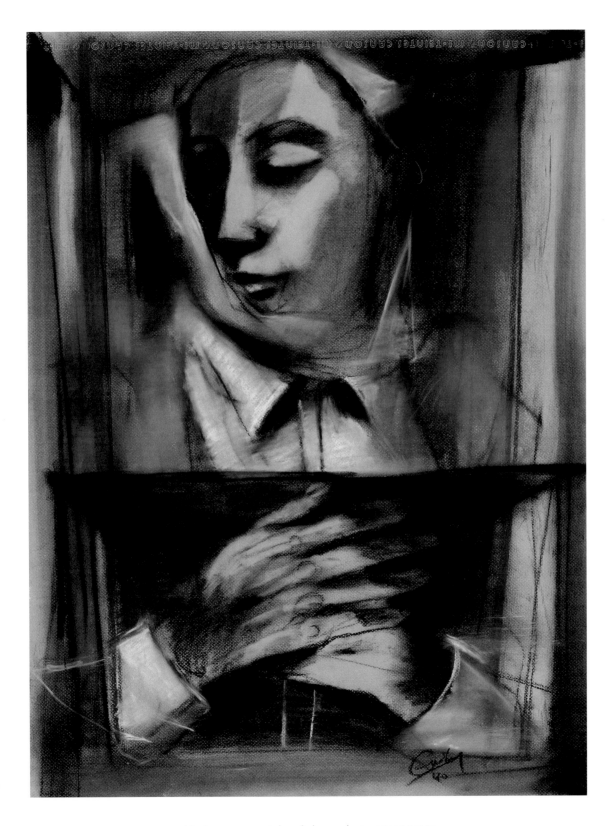

Marka, 2010, pastel and charcoal on paper, 30 x 22
Christ becomes one with those who commit to follow him.

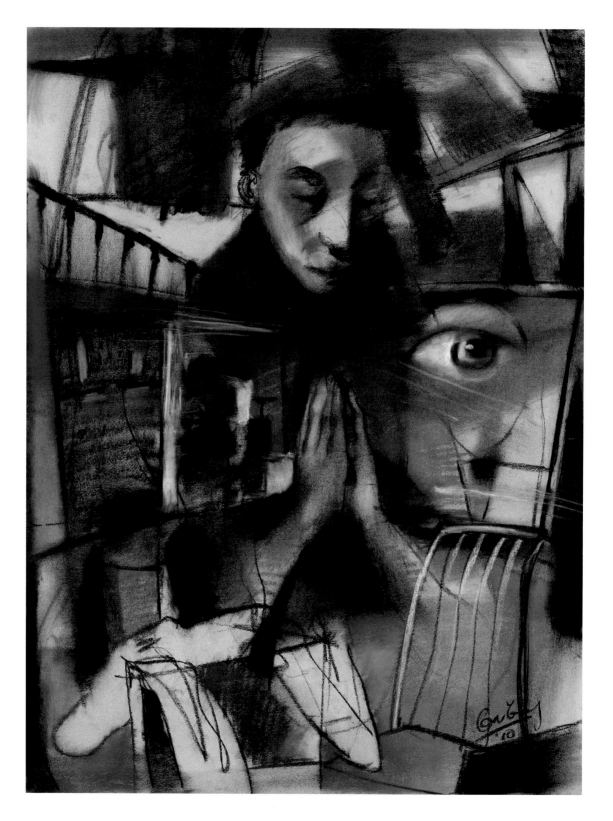

Dalangin, 2010, pastel and charcoal on paper, 30 x 22
The strength of will to persevere in the way, amid doubts and destruction.

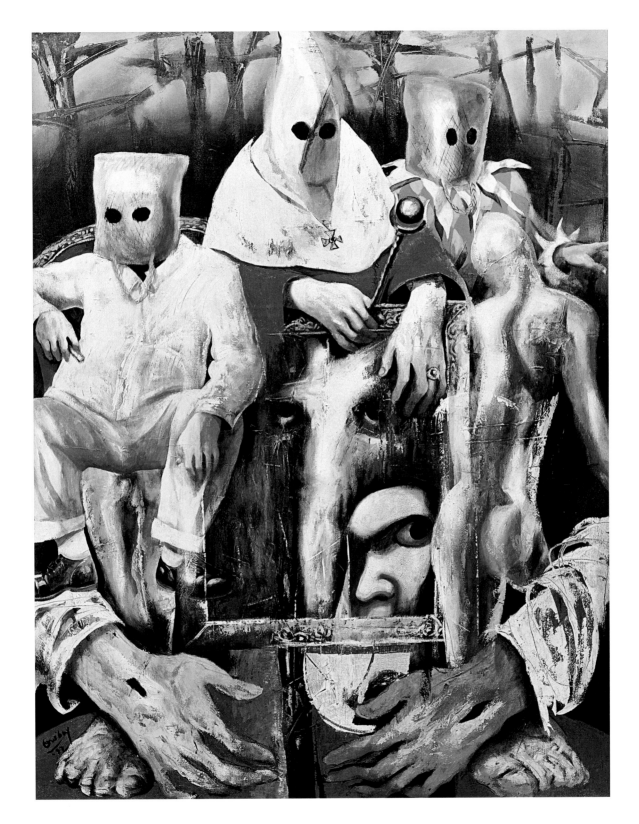

Tres Personas, 1999, oil on canvas, 64 x 48

How religious beliefs can become ideologies shaping worldviews that perpetuate institutions of power, selfishness, and deception.

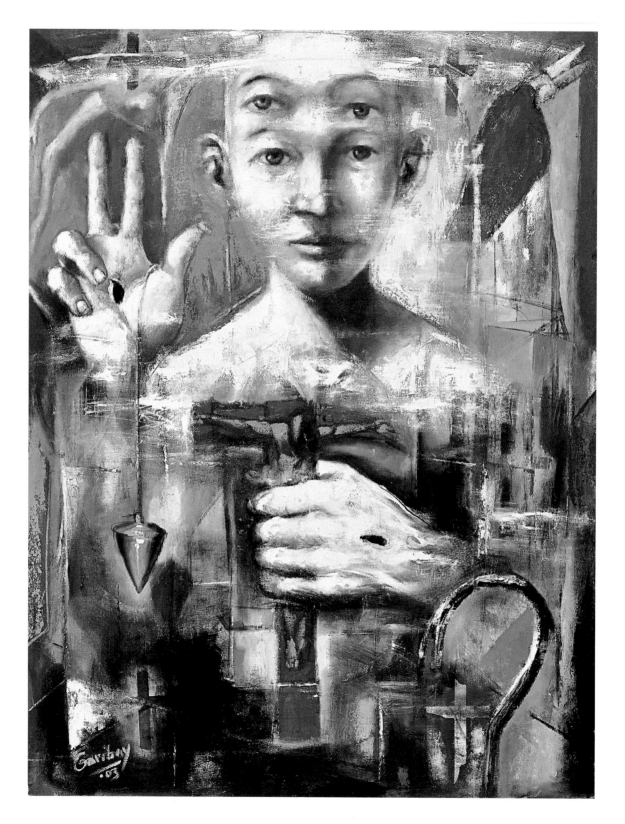

Resurrection, 2003, oil on canvas, 48 x 36

The event of renewal and transformation in which life is rebuilt (red hammer) along the way of righteousness (plumb line) and the old has been dismantled (crowbar).

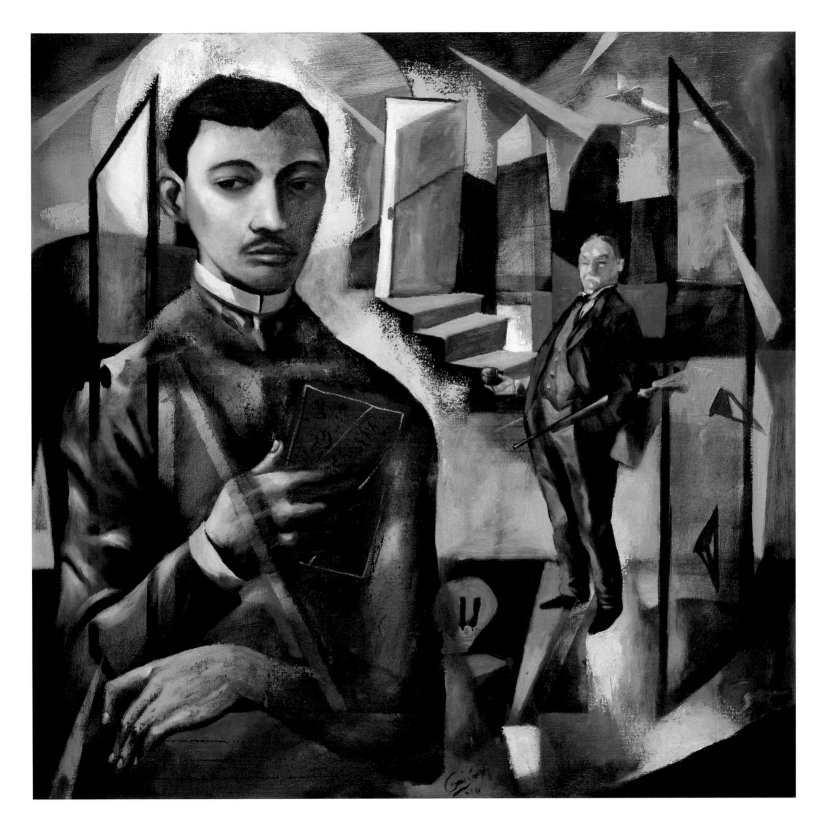

Hybrid, 2010, oil on canvas, 36 x 36
José Rizal (a Philippine national hero) as symbol of the Filipino as a hybrid struggling with identity, colonization, and alienation.

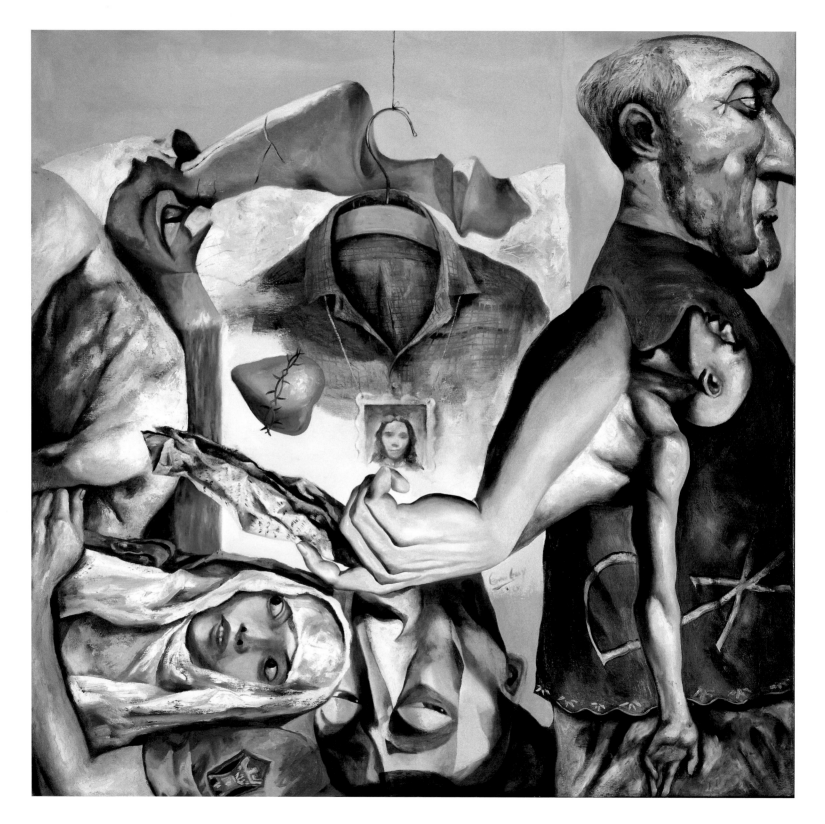

Indio, 2010, oil on canvas, 48 x 48
Macario Sakay, a Philippine revolutionary hero.

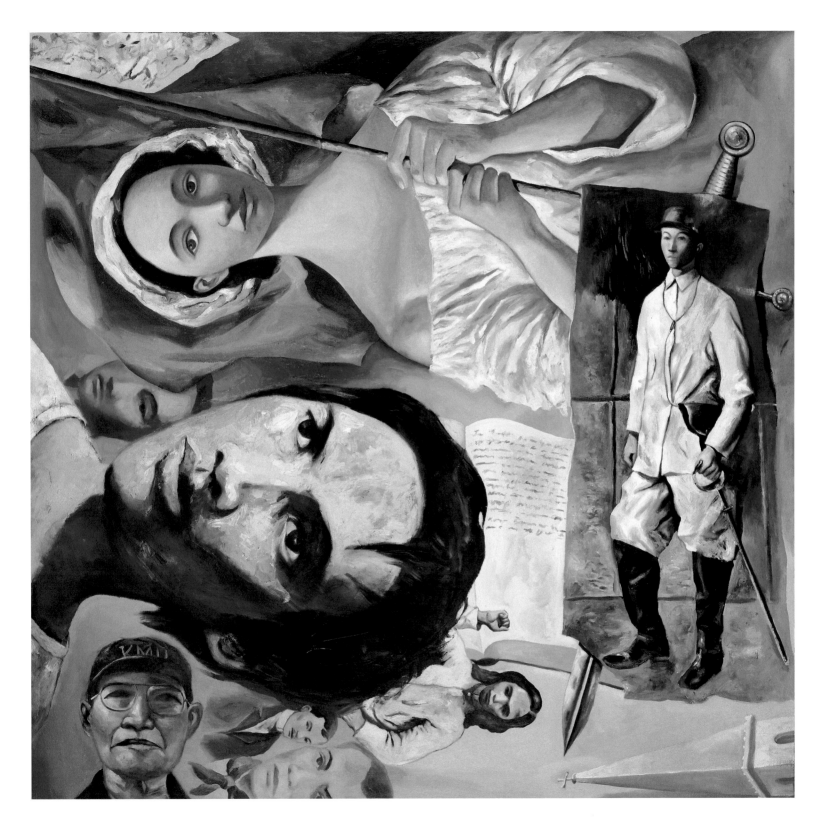

Eman, 2011, oil on canvas, 48 x 48
Eman Lacaba—activist, martyr, poet—who was captured and executed during the Marcos dictatorship.

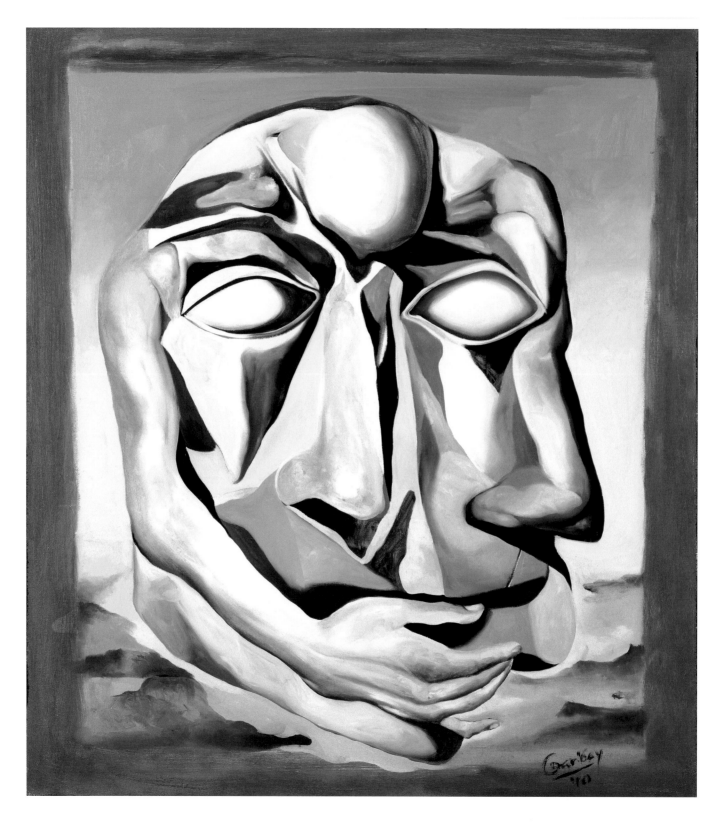

Empty, 2010, oil on canvas, 32 x 28

The act of surrender is the first step to real awakening.

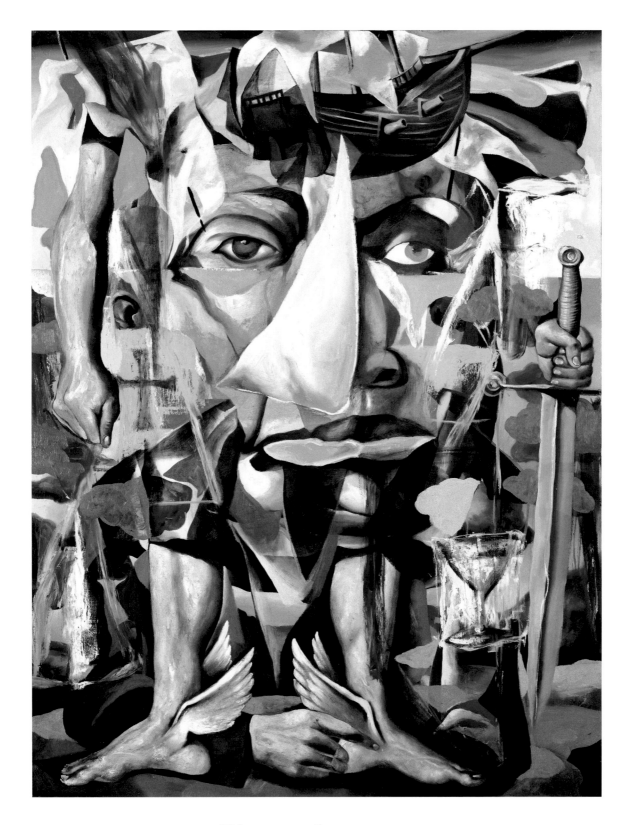

Misionaryo, 2011, oil on canvas, 40 x 30
How colonization obscured the benevolent intentions of the European missions.

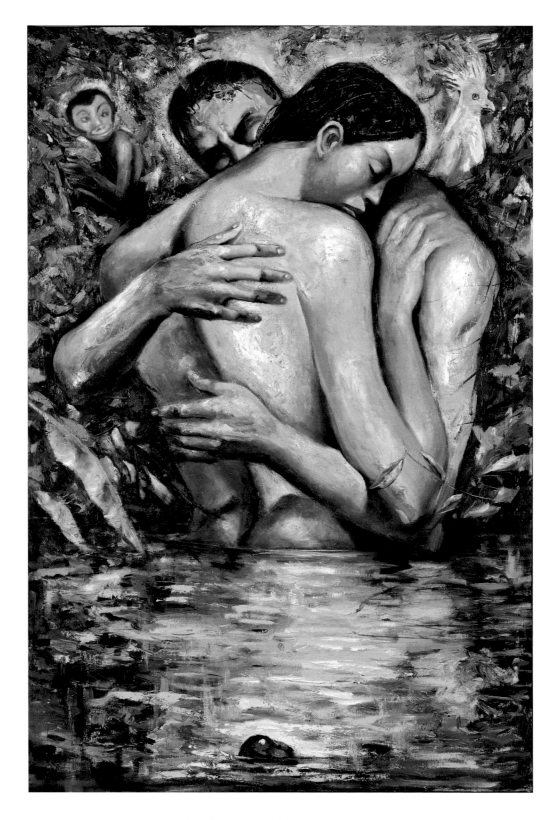

Ang Pasya, 2010, oil on canvas, 54 x 34

A scene from the Garden of Eden, where Adam and Eve chose not to eat the fruit.

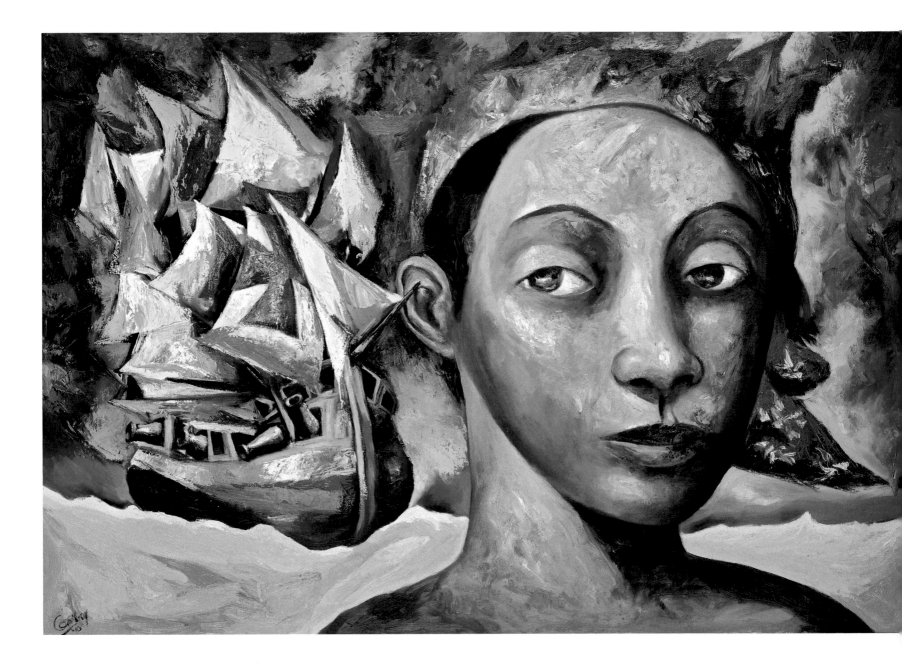

Ang Pagdating, 2010, oil on canvas, 36 x 52
Spanish colonization disguised as Christian mission.

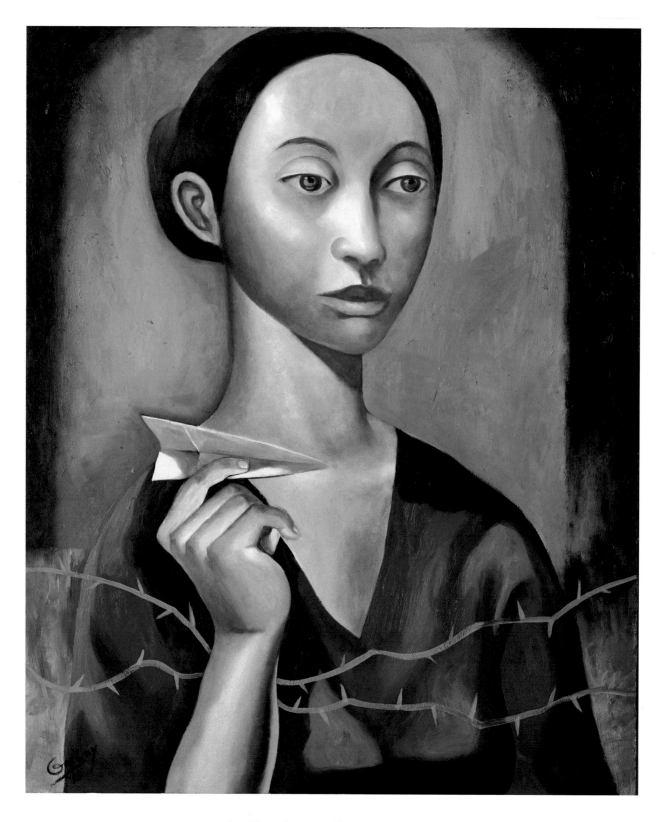

Ang Mensahe, 2010, oil on canvas, 30 x 24

About the plight of many Filipino women who work overseas, often as domestic helpers, some of whom get abused or mistreated.

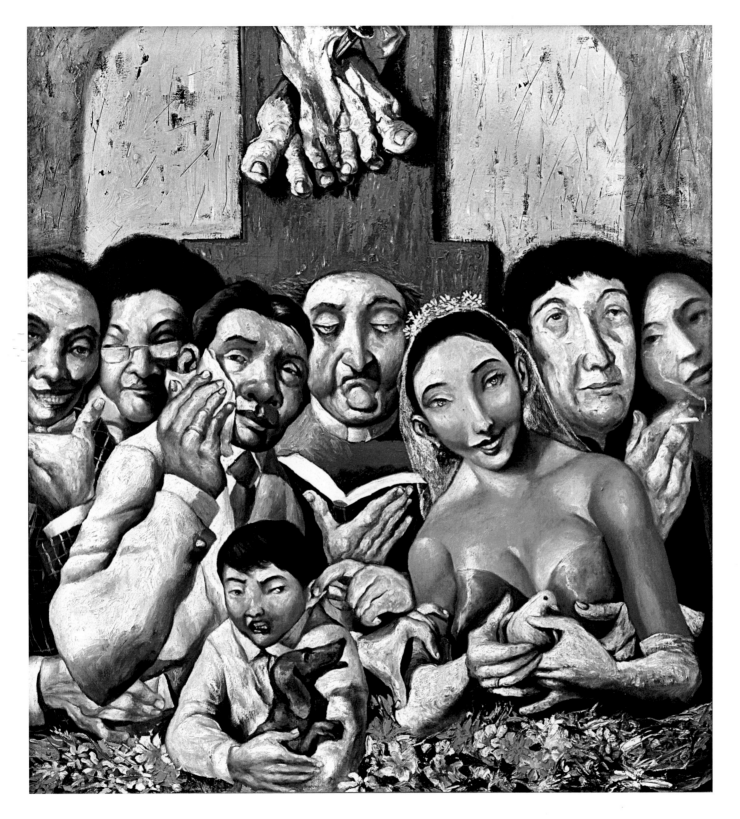

Kodakan, 2005, oil on canvas, 60 x 54

A colloquial term for picture-taking, in this case at a church wedding where celebrants and companions are oblivious to the feet of the suffering Christ above them.

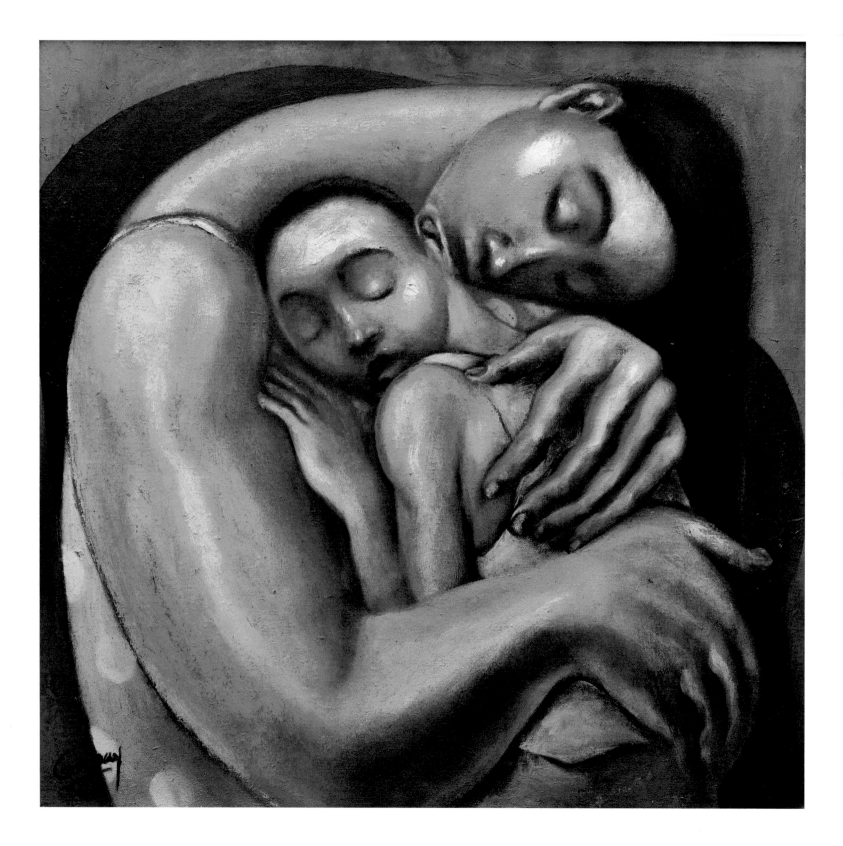

Kalinga, 2002, oil on canvas, 36 x 36

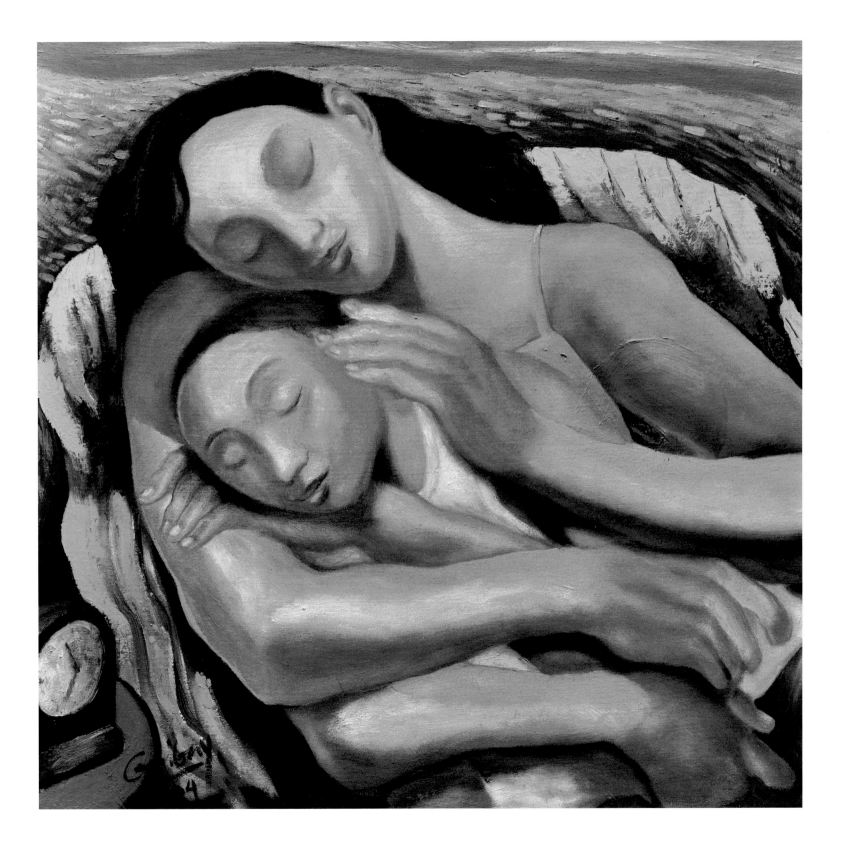

Tabing Dagat, 2004, oil on canvas, 36 x 36

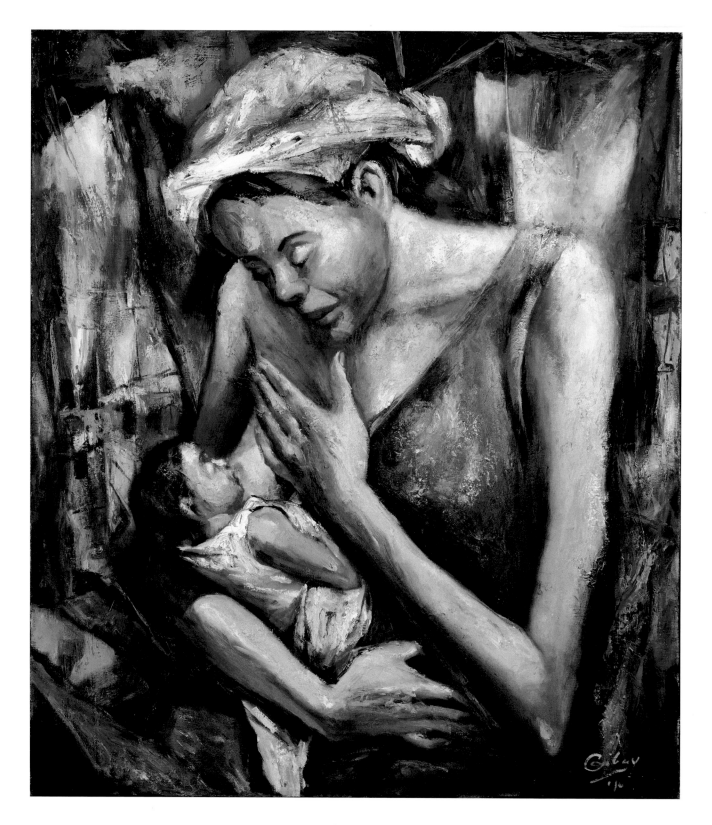

Ina, 2010, oil on canvas, 40 x 34
A reflection on God as a mother—life giver and nurturer.

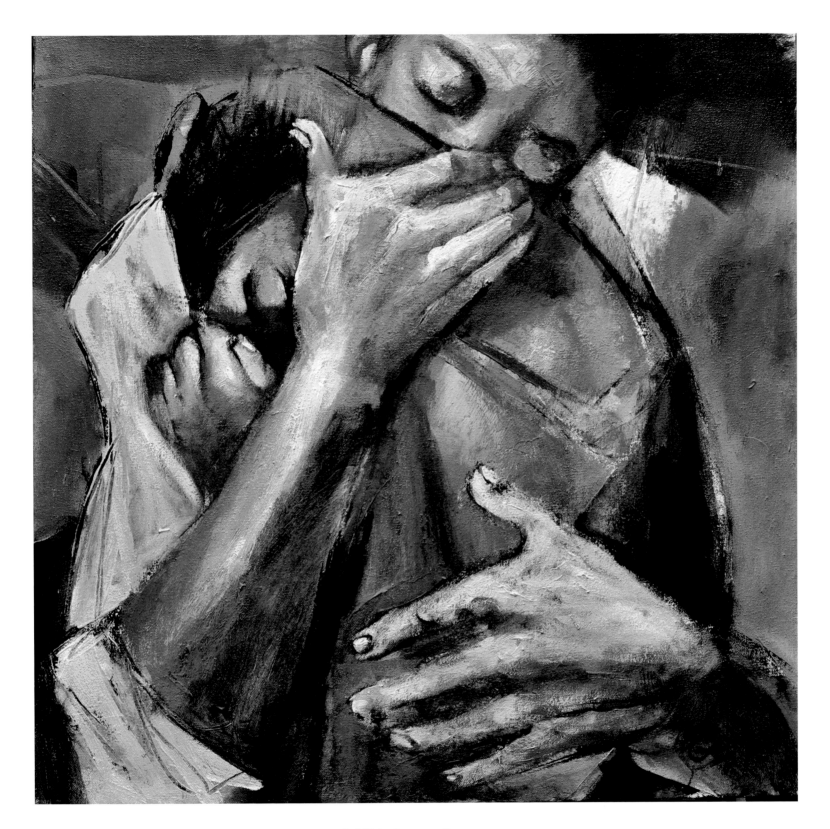

Ang Pagabablik-loob, 2005, oil on canvas, 24 x 24
The return of the prodigal son (Luke 15).

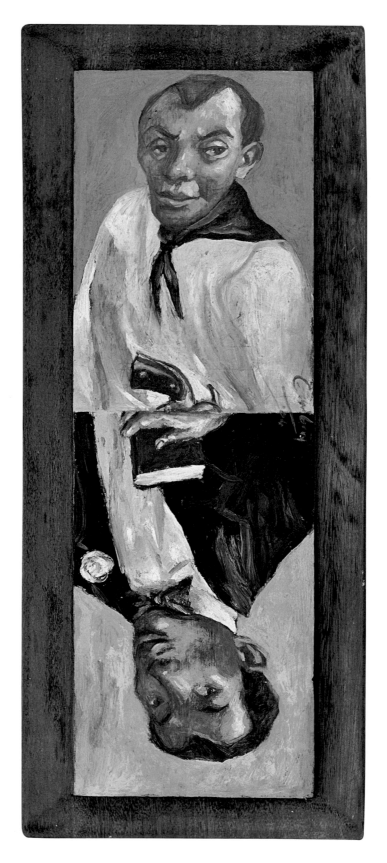

Baliktaran, 2006, oil on wood, 27 x 11

The two foremost heroes of the Philippines: one a revolutionary leader, the other a social reformer.

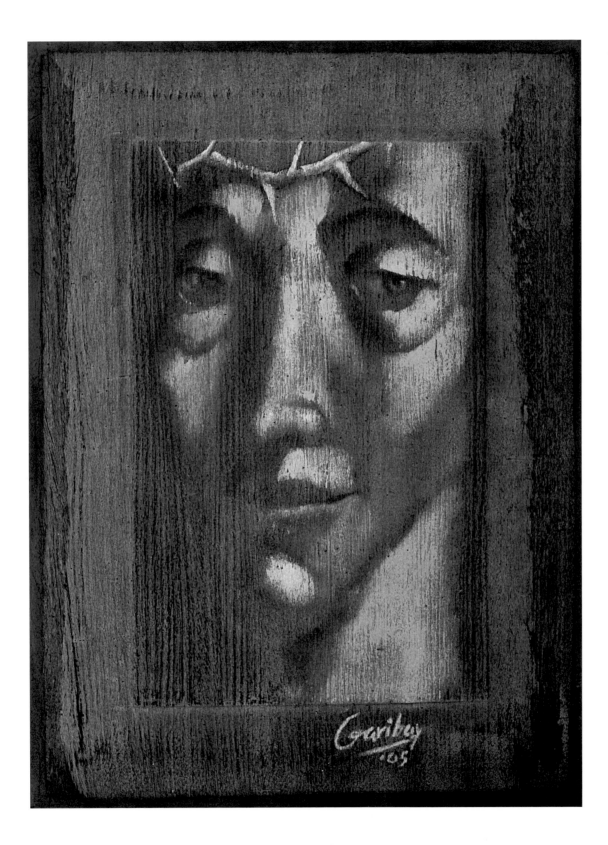

Anino, 2005, oil on wood, 22 x 15½

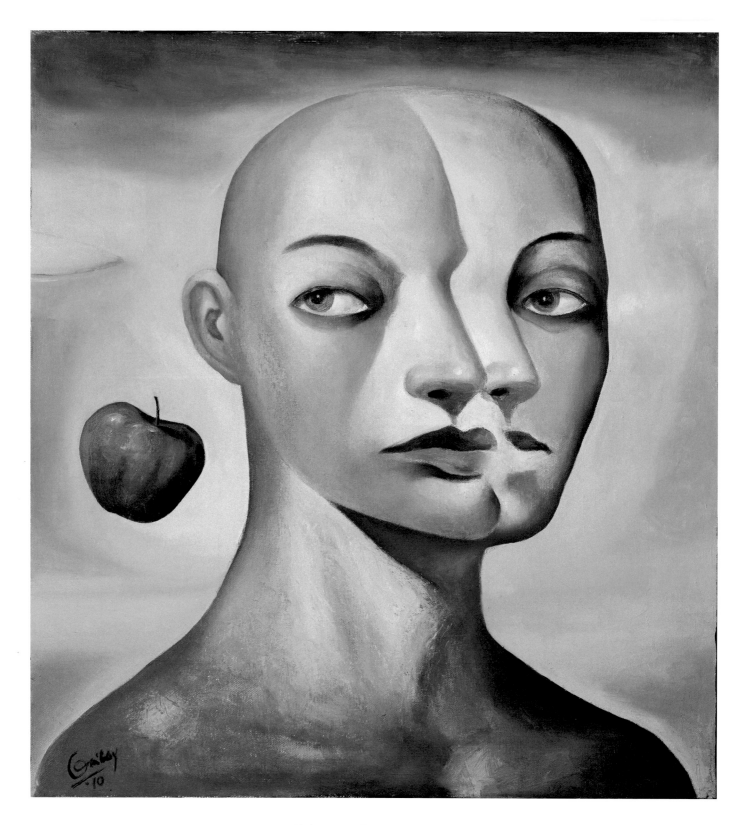

Alpha, 2010, oil on canvas, 21 x 19

In the beginning, before human awareness of the good and bad.

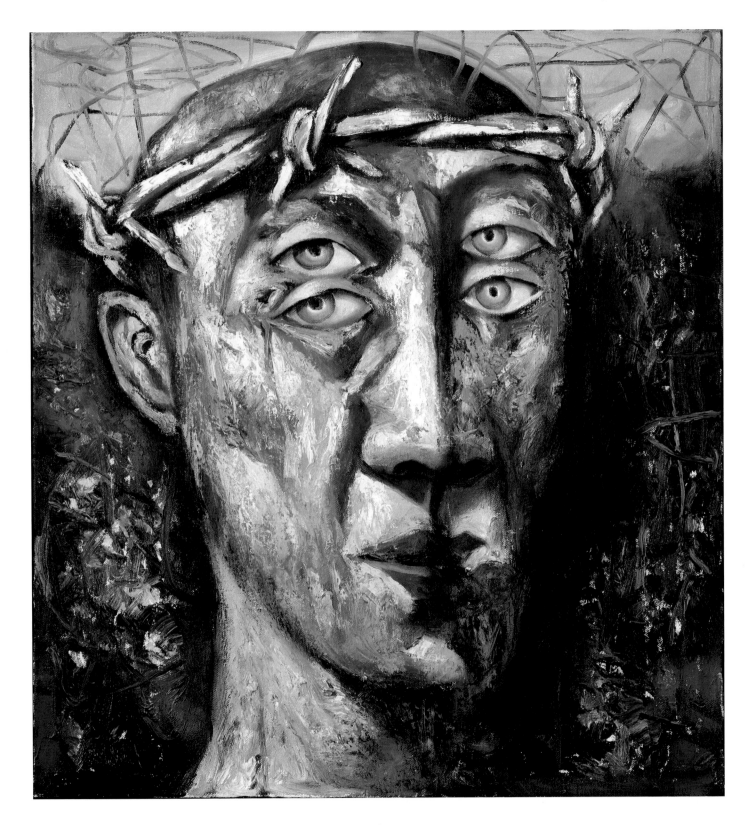

Omega, 2010, oil on canvas, 21 x 19
Transformation from human to divine for those who embrace the suffering that comes with the struggle against
dehumanizing powers (authorities) of society.

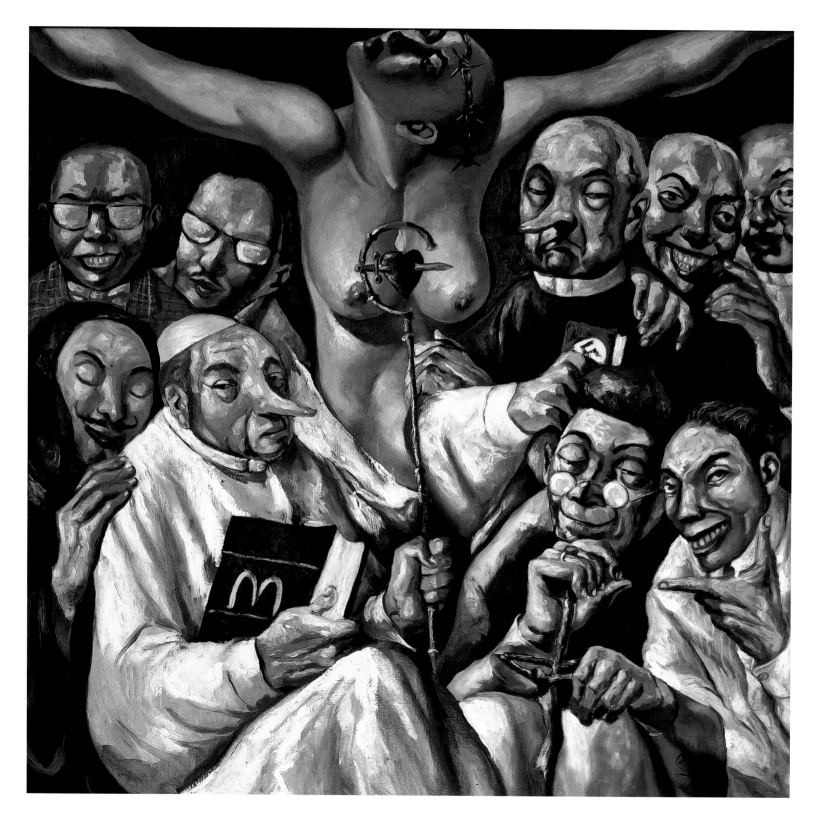

Boys' Club, 2003, oil on canvas, 48 x 48

How the domination of a patriarchal ideology legitimizes the unjust treatment of women.

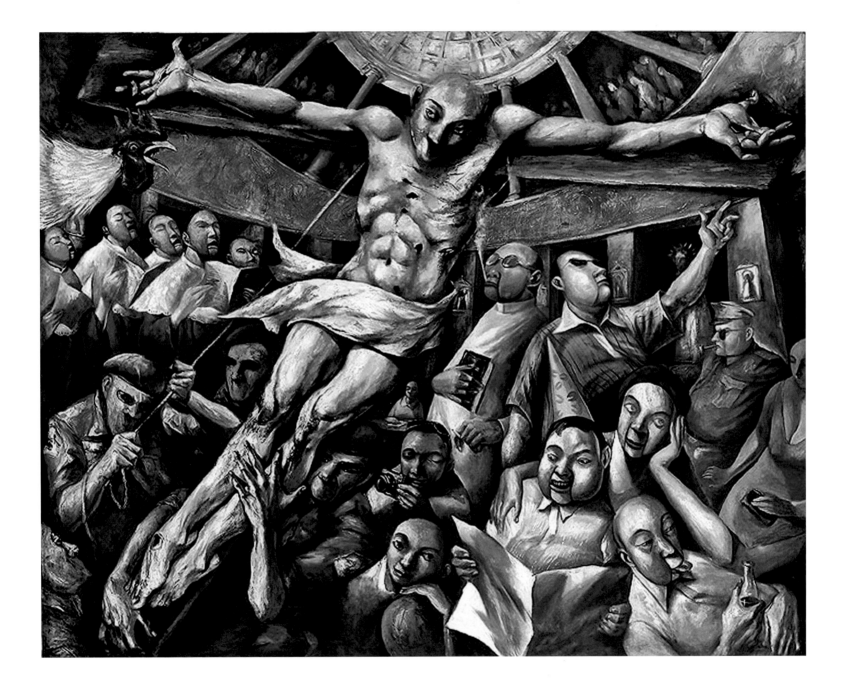

Bayang Magiliw, 2007, oil on canvas, 60 x 72

The first two words of the Philippine national anthem. It is a parody of Philippine society.

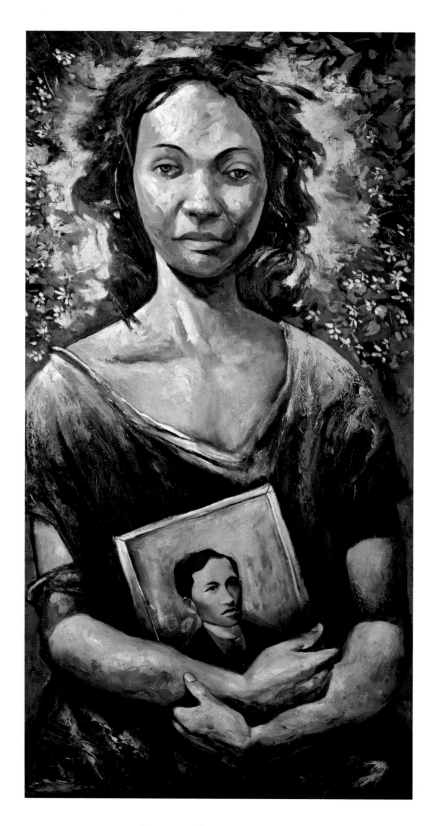

Sisa, 2011, oil on canvas, 52 x 27

A character in a novel by José Rizal (a Philippine national hero) who becomes insane upon
learning of the death of her youngest son, a victim of abuse by the Spanish friars.

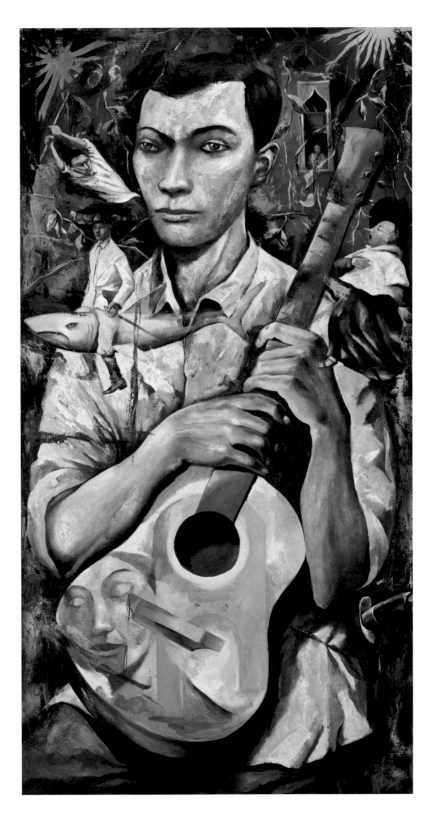

Sintonado, 2011, oil on canvas, 52 x 27
Andrés Bonifacio y de Castro, a hero and anticolonial revolutionary leader.

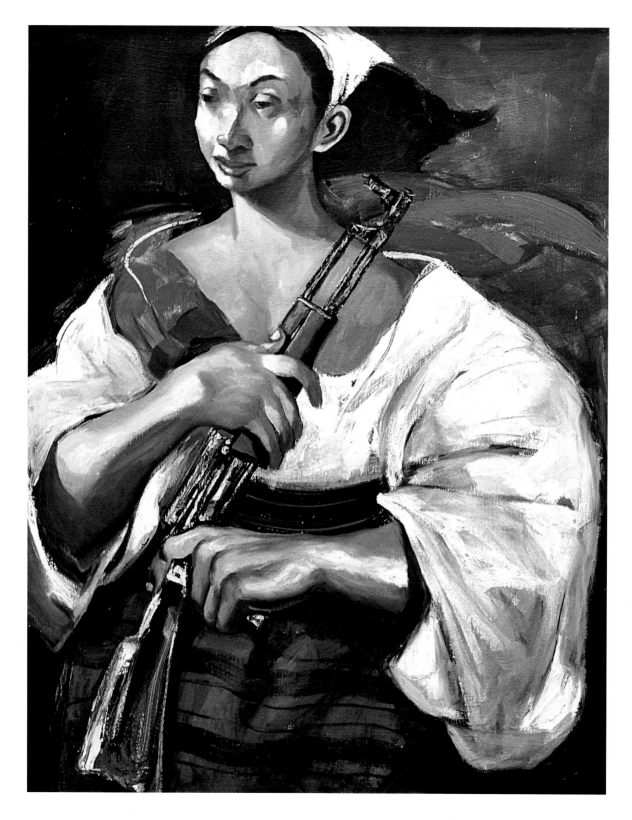

Gabriela, 2005, oil on canvas, 48 x 36
María Josefa Gabriela Cariño Silang, Philippine heroine of the eighteenth century.

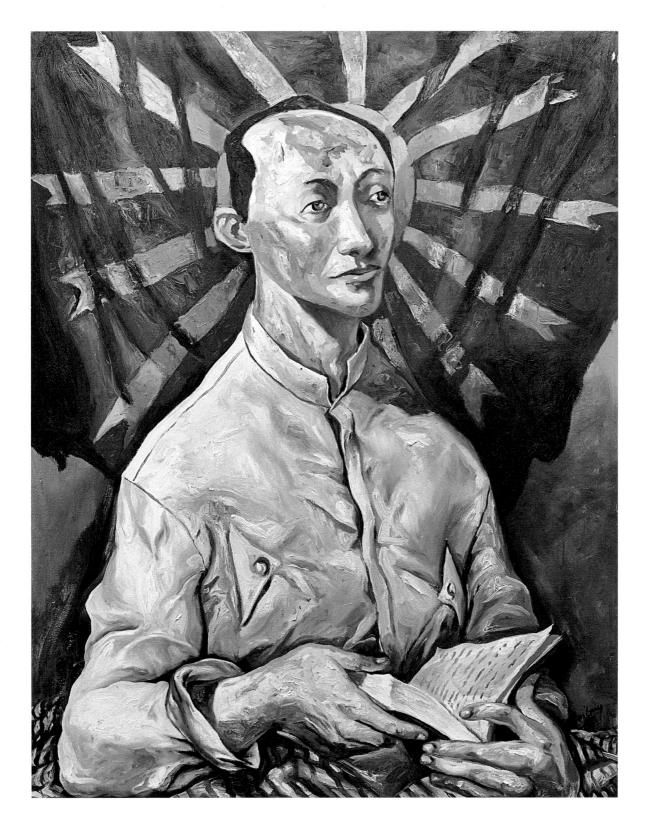

Tagapundar, 2010, oil on canvas, 48 x 36

Apolinario Mabini y Maranan was among the leaders of the Philippine revolution who drafted the Philippine Constitution.

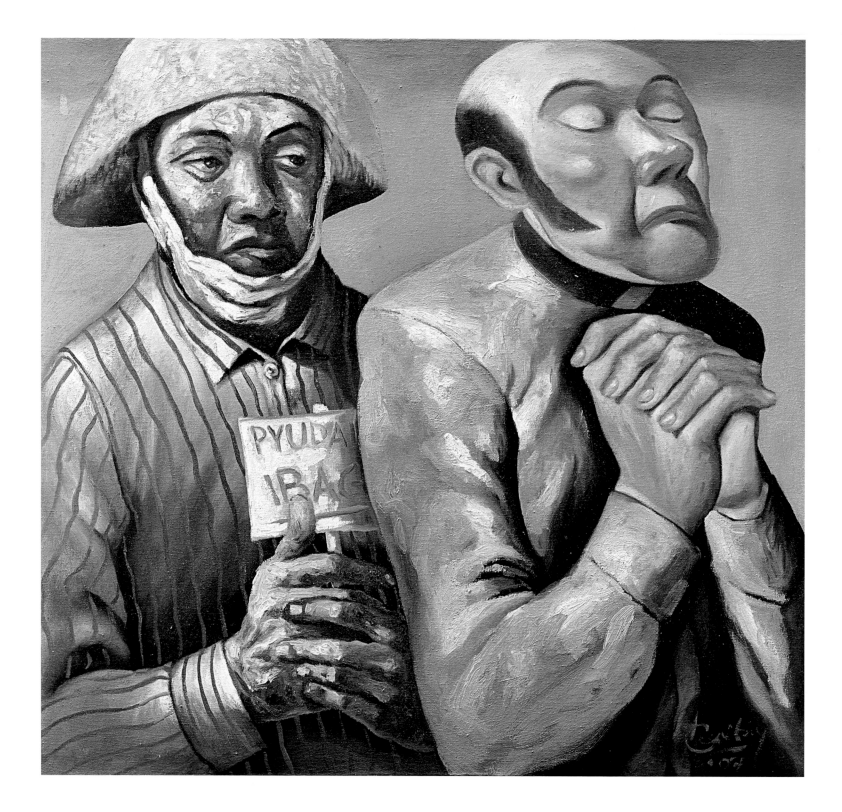

Pakiusap, 2007, oil on canvas, 24 x 24
A farmer seeking the help of a church official.

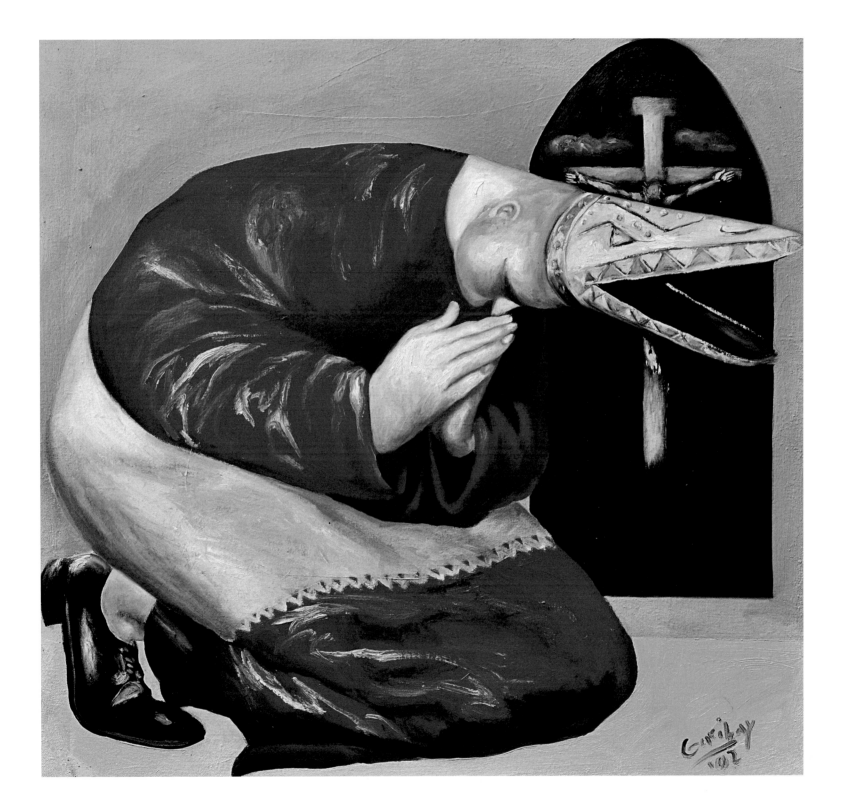

Taimtim, 2002, oil on canvas, 24 x 24

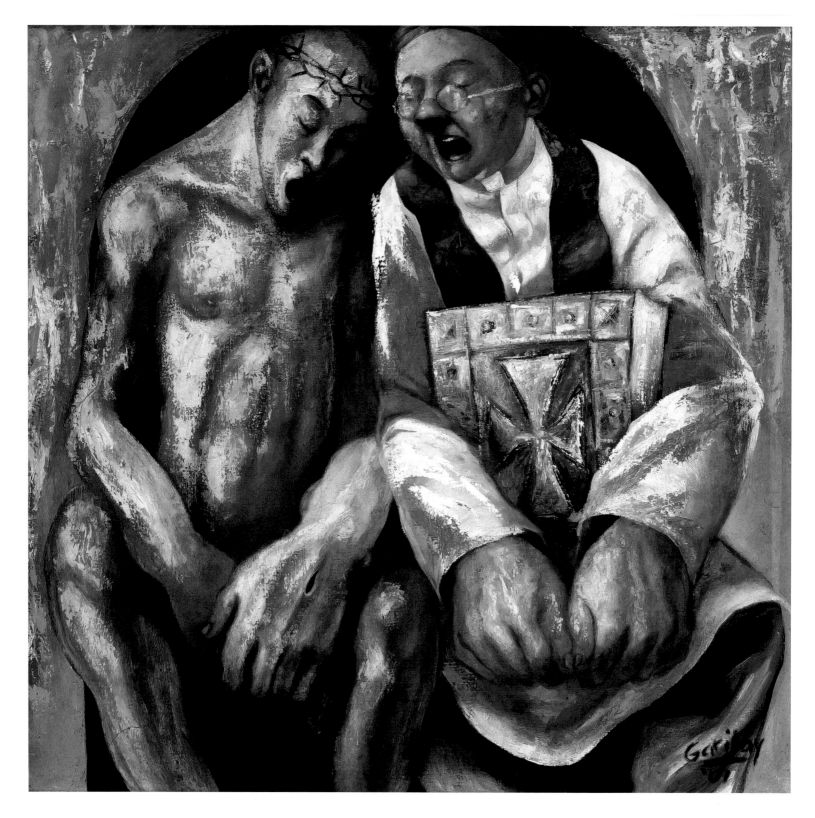

Duet, 2001, oil on canvas, 36 x 36

A flagellant and a church official.

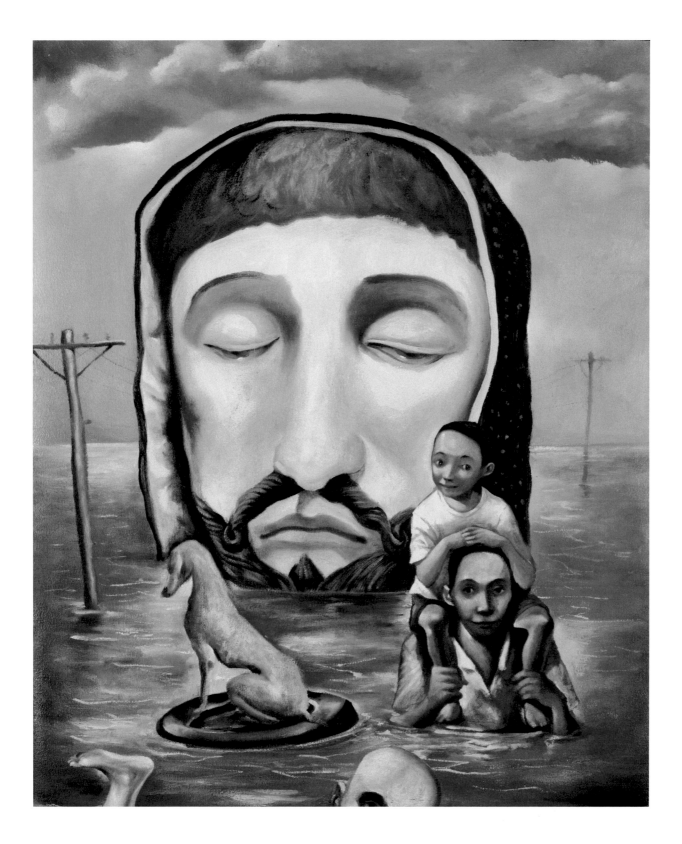

The Flood, 2009, oil on canvas, 36 x 28

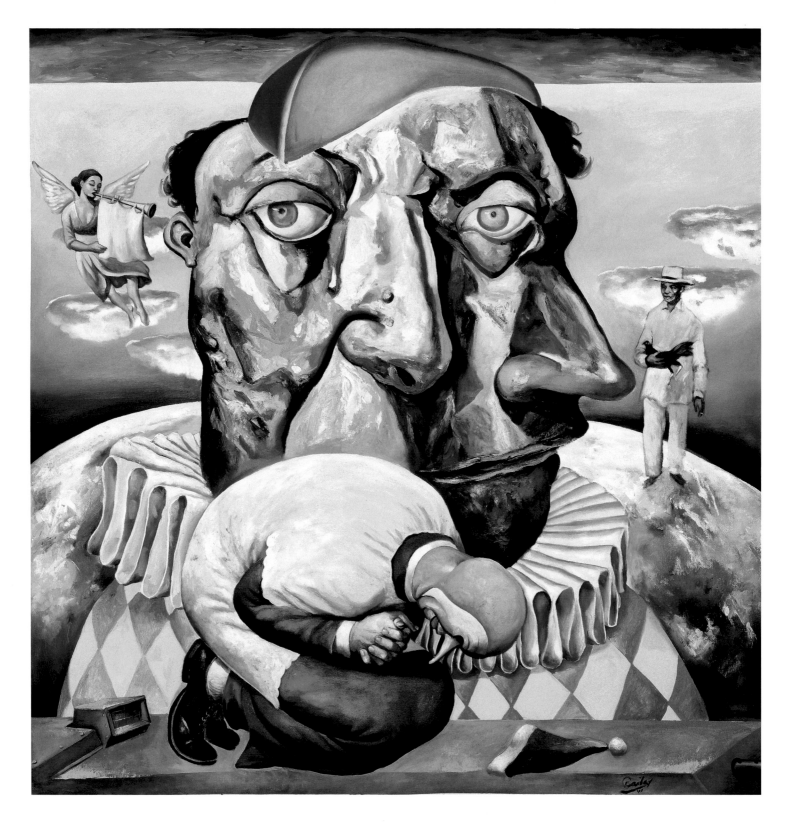

The Commission, 2011, oil on canvas, 54¹/₂ x 53

A convoluted picture of church expansion.

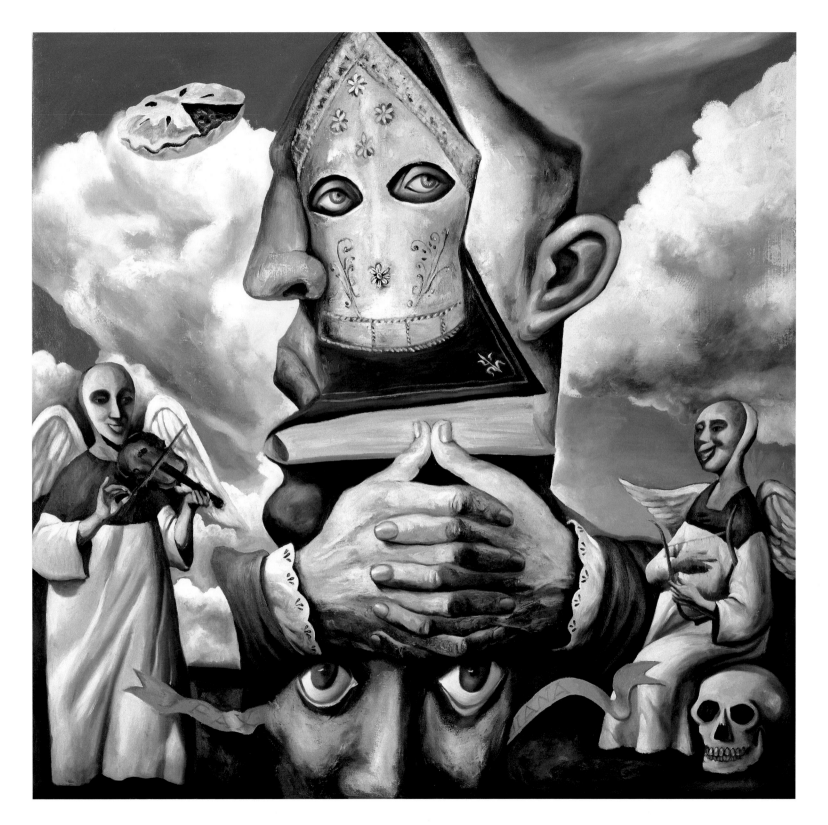

Worldview, 2010, oil on canvas, 48 x 48

A critique on a theology teaching acceptance of one's unjust fate for the reward of heaven in the afterlife.

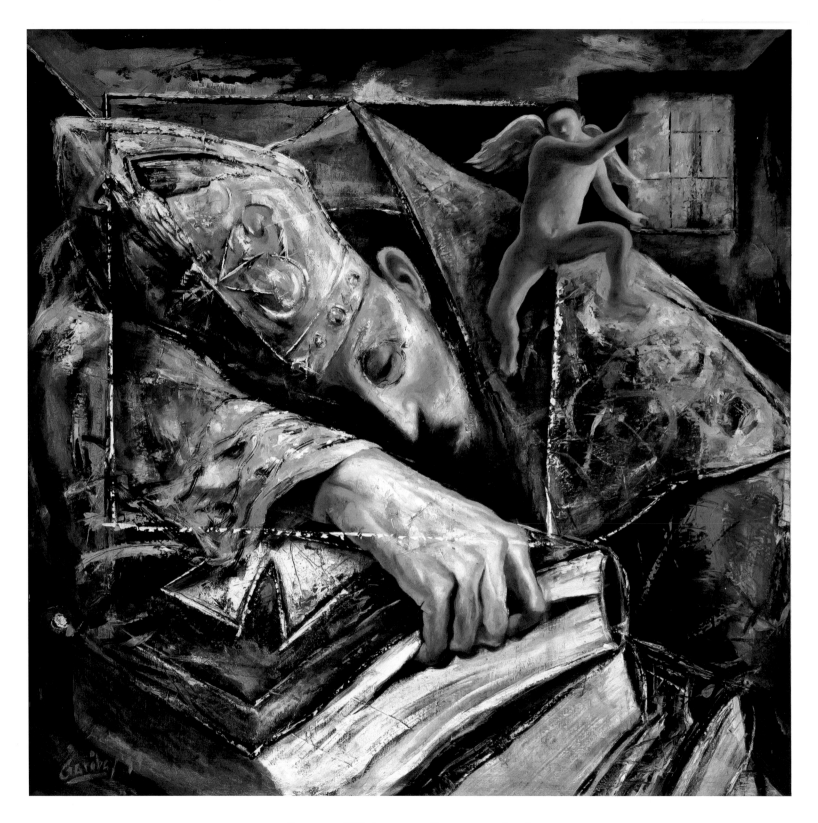

Dogma and Wisdom, 1999, oil on canvas, 36 x 36

Stagnation resulting from persistence in keeping some irrelevant traditions.

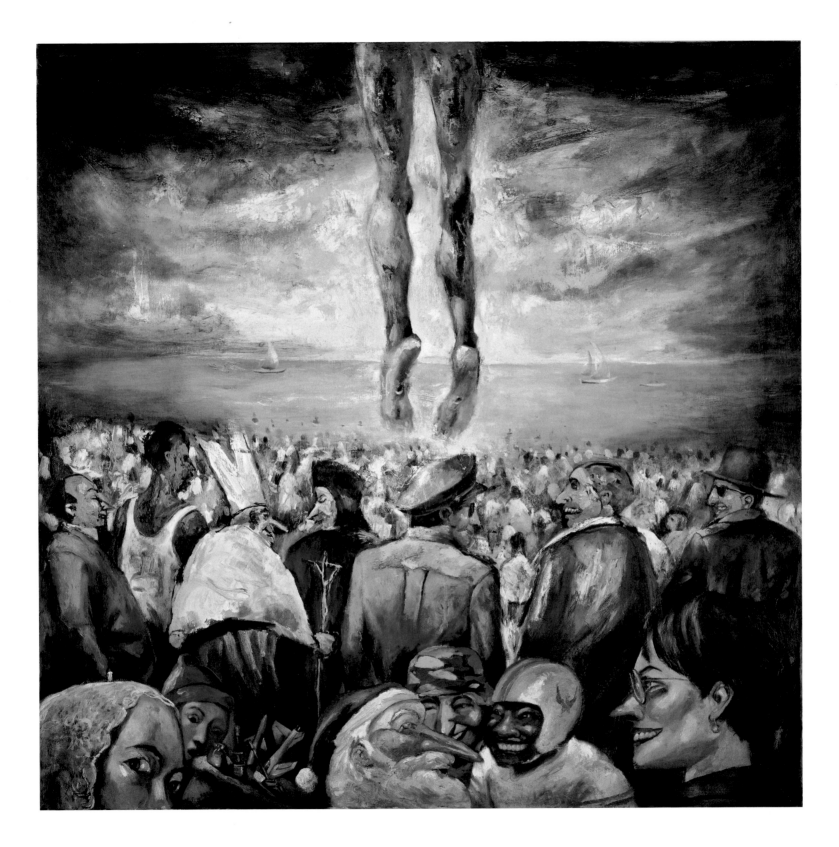

To an Unknown God, 2011, oil on canvas, 48 x 48

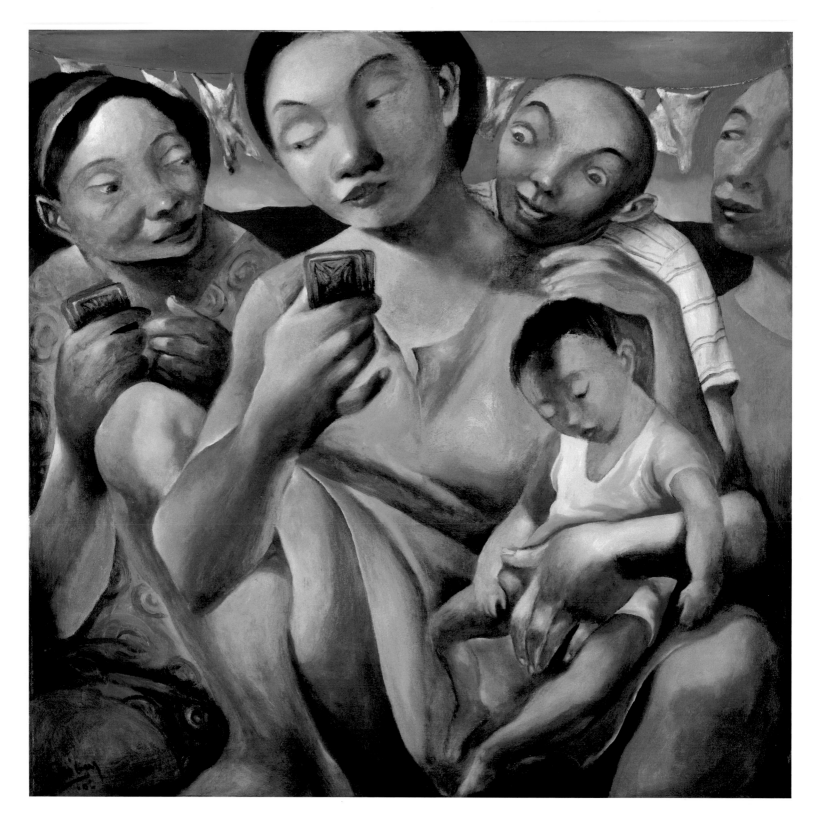

Tong-its, 2006, oil on canvas, 36 x 36
A card game usually played in neighborhoods to pass the time.

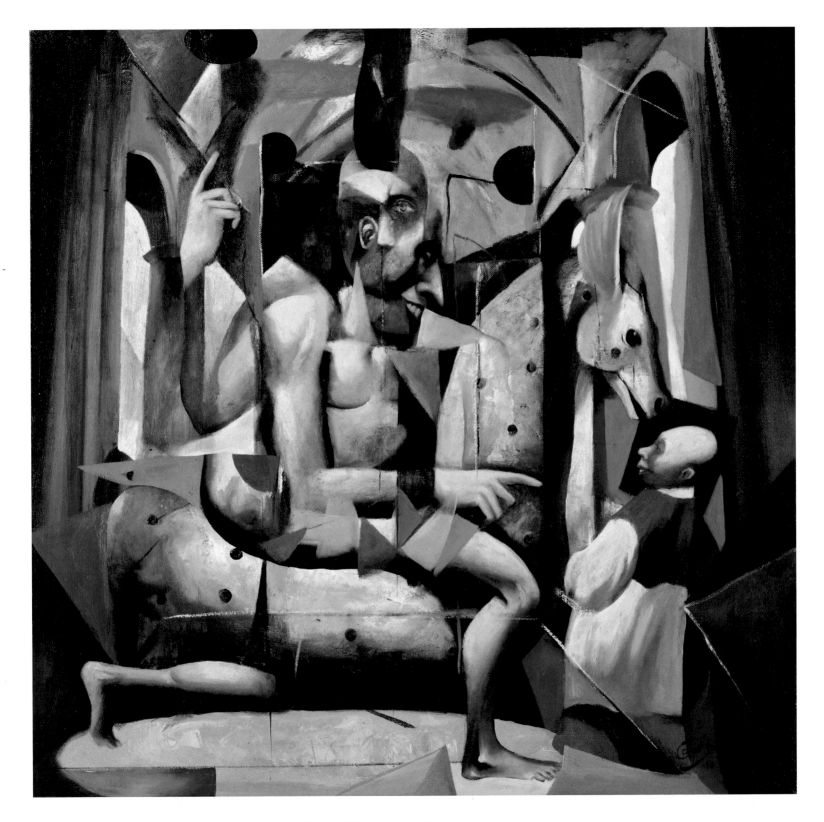

Bahay Misteryo, 2010, oil on canvas, 30 x 30
Points to a prescientific, premodern worldview that still lingers among many in the church today.

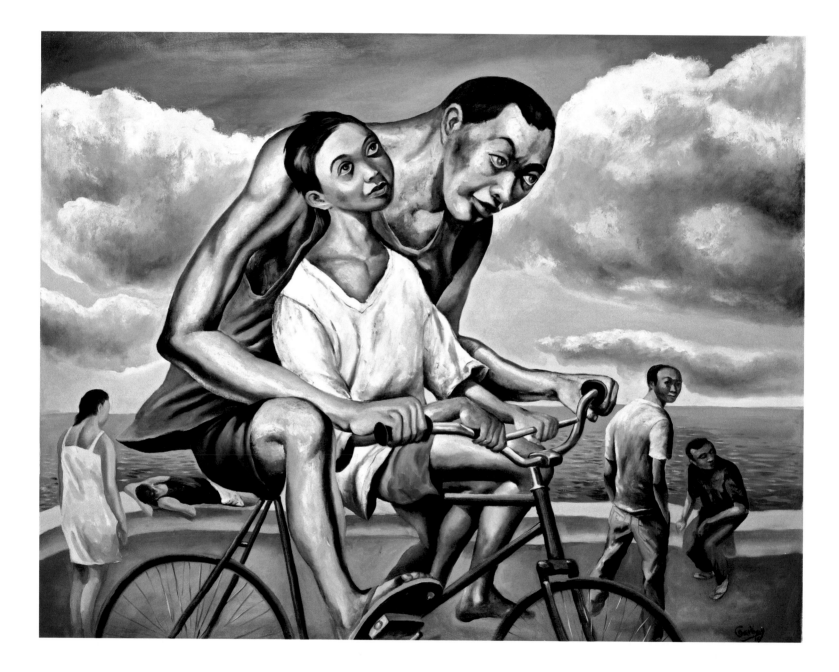

Sea Breeze, 2011, oil on canvas, 48 x 56

LIST OF ILLUSTRATIONS

All dimensions in inches